T0127730

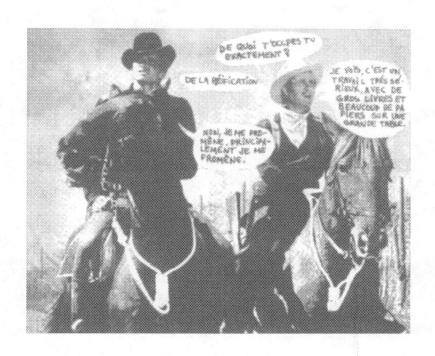

SEMIOTEXT(E) NATIVE AGENTS SERIES

"Cet ouvrage publié dans le cadre du programme d'aide à la publication bénéficie du soutien du Ministère des Affaires Etrangères et du Service Culturel de l'Ambassade de France représenté aux Etats-Unis."

This work, published as part of the program of aid for publication, received support from the French Ministry of Foreign Affairs and the Cultural Service of the French Embassy in the United States.

© 2008 by Semiotext(e)
Originally published as: *Tous les chevaux du roi.*
Copyright © 2004 Éditions Allia, Paris.

All rights reserved. No part of this book may be reproduced, stored in a retrieval system, or transmitted by any means, electronic, mechanical, photocopying, recording, or otherwise, without prior permission of the publisher.

Page 113: "Portrait of Guy Debord as a Young Libertine." Substance, Vol. 90, 1999. © 1999 by the Board of Regents of the University of Wisconsin System. Reproduced by permission.

Published by Semiotext(e)
PO Box 629, South Pasadena, CA 91031
www.semiotexte.com

Special thanks to Robert Dewhurst and Noura Wedell.
First page: André Bertrand, Le retour de la Colonne Durutti, 1966.

Design: Hedi El Kholti

ISBN: 978-1-58435-065-1
Distributed by The MIT Press, Cambridge, Mass. and London, England

ALL THE KING'S HORSES

Michèle Bernstein

Introduction by John Kelsey
Afterword by Odile Passot

Translated by John Kelsey

\<e\>

Contents

Michèle BERNSTEIN

TOUS
LES CHEVAUX
DU ROI

Roman

BUCHET/CHASTEL
Corrêa

John Kelsey

TRANSLATOR'S INTRODUCTION

The term "young" is required for advertising purposes.
And the kids, conscious of the beefsteak they're being
offered, produce nothing but merchandise on demand.
— Michèle Bernstein, *Potlatch* 15

An earlier, rougher translation of *All The King's Horses* was
undertaken in 2003–2004, and distributed one chapter at a
time as a series of pamphlets at Reena Spaulings Fine Art, a
gallery on Manhattan's Lower East Side. This serialized ver-
sion of Michèle Bernstein's first novel doubled as a sort of
gallery program, including in each chapter's layout minimal
documentation of recent events at Reena Spaulings, as well
as listings of upcoming shows and performances, some real
and some fictional. The translation was done in a hasty and
slapdash fashion, usually the night before an opening, with
some sections of the text interrupted by jpegs of contempo-
rary artworks and the bodies that gathered around them at
Spaulings, which at the time was known only by its street

address, 371 Grand. *Tous les chevaux du roi* was still out of print in France. My source text was a photocopy of a photocopy of the original 1960, Buchet/Chastel edition.

One reason for distributing Bernstein's book in this way was to create a line in time that would cross through the various, fleeting exhibitions at the gallery, some of which were installed and deinstalled in a single afternoon, and in a highly improvised manner. The gradual progression of Bernstein's chapters over the course of a year produced a narrative that ran alongside that of the gallery, which was also a sort of fiction, operated by several people under a made-up name, without a business plan or any prior experience in dealing art. This second or supplementary narrative—Bernstein's—was intended in a self-critical way, opening as it does with a boring art opening, somewhere on the Left Bank in the late-1950s. It wasn't hard to imagine the sort of work on view there: derivative, late-Surrealist abstractions, a living-dead avant-garde décor that was completely useless to the novel's young protagonists. In 2003, New York's contemporary art world—firmly installed in a renovated, bunker-like Chelsea, and experiencing a hedge-fund-driven boom unseen since the 80s, but even more extreme—seemed similarly devoid of possibilities. Art was functioning perfectly, but it was bogged down in itself and getting bored. It was clear that no new gallery could change the situation, but a fictional gallerist following in the stiletto-heeled tracks of Mary Boone, for example, performing an obviously poor imitation of an iconic New York power dealer, seemed to

offer the possibility of opening up a slightly more unpredictable space of activity, or at least some breathing room for those involved. The dealer Reena Spaulings stepped right out of Bernstein's first paragraph: "the gallerist was talking about her shoes, so that an important visitor would understand she was already distancing herself from the failure she felt coming," etc. We invented some artists too. So there was a deliberate piling up of fictions in one location, in a year that also marked the release of Bernadette Corporation's collectively-authored novel *Reena Spaulings* (Semiotexte, 2004).

The appearance of the novel *Reena Spaulings* further confused the identity and meaning of the gallery, which had meanwhile served as a meeting and writing place for the book's many authors, and which now shared its name. Partly under the influence of Bernstein, Bernadette Corporation was interested in re-appropriating an exhausted form, the novel, in order to say something insincere about New York after 9/11. A patriotic ghost of the city had been installed by citizens and police alike, the war was definitely on, and anything antagonistic to the cause was branded as terrorist. What we needed most desperately was fiction and Bernstein's post-existentialist, anything-but-sincere youth novel was attractive mainly in its knowing use of popular, banal literary (and cinematic) formulas as a means of rewriting and reinhabiting the city itself.

We had heard that Bernstein quickly disowned her own novels as minor commercial ventures, as not serious (in comparison to her husband Guy Debord's theoretical texts, for

example), but this was exactly what interested us: writing under the sign of commerce, but also disowned writing. What can we make of a text that insists on both its own commercialism and its refusal of authorship? And what could we do with the idea of a sort of postliterature, or posed literature, now, in a city that felt increasingly posturban, and whose faux-bohemian art world was constantly, miraculously out-lasting its own death? In addition to the Bernstein novel, other models for *Reena Spaulings* included *Gossip Girl*, a brand of sexed-up corporate literature popular among teenagers in 2002, which was also set in New York, and *Premiers matériaux pour une Théorie de la Jeune-Fille* (Editions Mille et une nuits, 2001), a "trash theoretical" tract authored by the militant collective Tiqqun, in France, which appropriated the jargon of contemporary youth and womens' magazines in order to critique the increasingly bio-political aspects of lifestyle consumption. The *jeune-fille* was the new face of control in this terrorized, cleaned-up, *Sex and the City* city, and this pretty face was our own.

Another reason for picking up *Tous les chevaux du roi* in 2003 was its ambiguous quasi-feminism, especially when read in relation to the male-dominated writings of the Situationist International. There was something awkward and problematic about Bernstein's voice, or her style of fabulation, which was difficult to reconcile with the mythic, and by now respectably academic domain of SI theory. Indeed, in all the many recent books on Debord and his legacy, Bernstein's fiction has been efficiently disappeared into the

footnotes. And especially in the context of a semi-wild, boyish contemporary art world, what seemed unsettling and so full of potential for us was the false sincerity of the novel's Françoise Sagan-esque narration, which retold a season among the free-living SI as if it were a breezy but jaded romance for teenaged girls. The names have all been changed, but it's clear that Bernstein, Debord, Asger Jorn and others are being rewritten as flimsy parodies of themselves. There's even a drunken moment in the novel where the characters address their own fictional status: "We're all characters in a novel, haven't you noticed? You and I speak in dry little sentences. There's even something unfinished about us." What seemed useful here was the strategic return of fiction as a way of opening up another sort of distance toward what was being lived by Bernstein and the SI, and theorized in serious books signed by Debord. By rewriting the Situationist saga as a young woman's problem, as a sort of *Gossip Girl* paperback or knock-off *Bonjour Tristesse* (whose author Debord & co. insulted in the pages of their review *Potlatch*), replete with arch social observations, flirtations, manipulations, and heartbreaks, Bernstein momentarily re-appropriates a history and an experience that are typically represented in equally posed, yet decidedly masculine and heroic modes. Her novels may indeed have been cynically commercial jobs, but it's doesn't seem unlikely that they also served a therapeutic purpose for their writer, as a way of making sense of her position in relation to Debord and others at the time. Roger Vadim's super trendy movie adaptation of

Choderlos de Laclos's *Les Liaisons Dangereuses* starring Jeanne Moreau had just been released in France, and by restaging the difficult, libidinal side of the Situationist experiment in that film's modishly libertine terms, Bernstein becomes both star and spectator of her own story. As a kind of performance, fiction is a means of putting oneself and one's problems at a distance, of getting rid of oneself.

Whatever Bernstein's intentions were at the time, it is possible to read her novel as both a glamorization and a critique of the very milieu she was participating in, of her whole world. A *dérive* rewritten as Pop fiction is not exactly the same *dérive*. And with *All the King's Horses* and *La Nuit*, the *détournement* of trendy literary genres is also and at the same time an ironic *détournement* of the SI itself by Bernstein, who we remember is already abandoning her role as author of these novels. We like these distancing effects, and the possibilities of disidentification that flourish as soon as we begin to operate under the sign of fiction.

This novel may not be a great, or even a good book. All it ever wanted was to escape its young author, and maybe to make a little money. It is a hack job, and knowingly derivative, but interesting for that. Bernstein also earned money writing horoscopes for horses in the racing columns, and sometimes by reviewing contemporary fiction. There was no way a writer like that could maintain the pose of the next Françoise Sagan for long, it would be indecent (as her character Geneviève might say), and probably impossible next to Debord (or Gilles).

If, following the Lettrist International, the SI was the first postwar effort to politicize youth culture in Europe, it was also capable of performing the very process it despised: packaging and marketing a lifestyle product for young consumers. Around this seeming contradiction, countless present and future games can still be elaborated. Following a general disenchantment with official, party Communism, unforeseen communisms can still be found hiding, travestied and momentarily neutralized, in used-up forms such as the novel, or even right here in the mirror, in the self-controlled and controlling image of the *jeune-fille*. She is our very condition. It's only a question of how we use her.

for Guy

I

This mixture of blue scarves, ladies, armor, violins in the room and trumpets in the square, offered a spectacle seen more often in novels than elsewhere.

Cardinal de Retz

1

I don't know how I realized so quickly that we liked Carole. I'd never heard anything about her until the day before, in a little gallery packed with that crowd that always shows up at the openings of painters destined to be unknown. The few ex-friends I met there were precisely the ones I would have preferred never to see again. In a voice that was too loud and tried hard to sound worldly, the gallerist was talking about her shoes, so that an important visitor would understand she was already distancing herself from the failure she felt coming. But unlike your typical art opening, this one was no cocktail party: there was nothing to drink.

Desperately scanning the room for Gilles, I saw the painter talking to him animatedly. A little group was already forming around them. This was a bad painter and a charming old man, the product of an obsolete modernism. Gilles was answering him without seeming bored and I admired his ease. The old painter had already been forgotten a generation before ours, but this did not discourage him at all. He adored us. Our youth confirmed his own, I guess.

And me, I was trapped in a conversation with his wife.

"You must meet my daughter," she said. "She's almost your age, but still so immature. Your company would do her a lot of good."

Indulgence hardly goes with boredom. I appraised the lady's dull friendliness. It was hard to picture myself taking this slow girl under my wing. But you have to be interested in people. I asked what the little girl was up to.

"Painting. I think she has talent, but she hasn't found herself yet."

"Like her dad," I said carelessly. This was when I learned she wasn't in fact Francois-Joseph's daughter, but the product of a previous marriage … I ended my sentence by warmly assuring her I'd love to meet Carole. Was my attempt at enthusiasm convincing? I wished Gilles were in my shoes. He seems naturally nicer than me.

But finally, after telling me about her daughter's best friend Beatrice, who wrote really good poems for her age, and to whom she was planning to give the Rimbaud book she'd just bought, she invited me over for dinner the next day, with my husband.

The dinner was fun. Francois-Joseph, no longer worried about the fate of his canvases, was living it up. His friends paraded out—in the usual order—all the ideas from thirty years ago, which was amusing. People from those times allow so much room for sick humor that even their stupidities can

come off with a certain ambiguity. When the charms of the one who sold the paintings but didn't serve any appetizers were sarcastically evoked, Francois-Joseph defended her big hips.

"Not like you, Carole," he said. "You still don't have much to please the misters."

"Style's catching up to me, Francois-Joseph," she answered, undulating gracefully in her chair.

Francois-Joseph was so visibly sensitive to this style that I couldn't help getting behind his awkward attempts to pull Carole out of her shyness. No doubt he'd been stuck in this false position for a long time. It was because she was the object of such annoying attentions, probably, that I watched Carole.

A twenty year old girl easily makes it understood to fifty year old men that they're out of the picture, and this one better than most. I took advantage of the moment she went into the kitchen to make coffee. I went to help her.

I felt myself submitting half-heartedly.

On her feet she seemed so small and incredibly slight. The mussed bangs, the short blond hair, dressed like a model child in a white crewneck and a blue sweater, she obviously didn't look her age. Her clumsiness was studied: Carole wasn't making coffee but chaos, ostensibly. This was to give me a chance to fail, either by exposing the slightest domestic capacity, or by stupidly offering advice.

Nothing works better than a trap avoided. The detachment I'm capable of when making water run, or finding cups, would slyly distance me from the group discussing obscure

editions at the table. Together we served a dark liquid that provoked a friendly indignation. Objects of their general reproach, we inevitably felt like accomplices. Exploiting this advantage, I turned the conversation back to Carole, a little ironically, speaking like a grown-up now with her parents. Francois-Joseph, happy to busy himself with her, wouldn't shut up. Disconcerted, she kept quiet. I gathered that she lived far from here, in the 16th arrondissement, and that she played guitar. Gilles was quiet too, and watched us with an interest I recognized.

But it was my idea to take the girl in our taxi. And when Gilles caught up with me in the hallway and sweetly asked what we were up to now, I answered:

"A conquest, of course."

I don't remember talking in the taxi. I was fine, I was tired. Gilles would naturally take over now, if only out of politeness. The story was easy for him to follow. We passed the Pigalle, where there was an all-night deli. We got some wine and some salted almonds. We had to give this night a festive feeling. Carole asked us to buy her pickles, as a favor, observing our surprise. Gilles ordered an extravagant quantity, plus some onions in vinegar, some capers—who knows— offering them ceremoniously to her. My contribution was in the form of red and green pimentos, not ugly to look at and, as an added bonus, inedible.

Each in our role, charming, charmed, we climbed eight flights, turned a lot of corners. We arrived in an attic. As she should have, Carole lived in a maid's room, which she paid

for by giving lessons to friends' kids. So she enjoyed her total freedom, she said. No doubt her parents wouldn't have refused her staying with them, but in that case she wouldn't have been able to broadcast—to herself and to others—such a fiery claim.

We were sitting on the floor, like Indians in the cramped room. Gilles showed Carole how to open a wine bottle by tapping it gently and repeatedly against a wall. We began drinking again. Carole was good on the guitar. All of the sudden, very modestly, she changed from her pleated skirt into jeans. "I buy them in the boys' department," she was saying. She sat cross-legged on her narrow bed, facing us. Carole sang well, and classic songs: girls who are beautiful at fifteen, their boyfriends gone to war. Girls who lose a golden ring by the riverside, lamenting the passing of the seasons, who never give up on love. Girls who go into the woods, girls one misses later, at sea, and the voyage will never end.

I say to myself she's no idiot, and congratulate myself for having discovered such a charming creature. Anyhow, Gilles liked her. He'd bought her all those pickles and was speaking to her in his beautiful, serious voice. I liked her too. My feelings, however, rarely went further than this.

She drank correctly, this girl, for a twenty year old. Sometimes straight from the bottle to show that she was a liberated woman: watching me from the corner of her eye, no doubt waiting for the moment I wouldn't be able to hide some sign of jealousy. She sang in a slightly lower voice now, slightly more childlike. The tobacco, she said, but I knew she wanted

to be seductive. And, also to seduce us, she remembered some touching anecdotes to show how young she still was, how naïve, how she put her trust in all the good, poetic people. Her guitar was a faithful animal that followed her everywhere. She didn't understand or like anything besides painting and the sea. And, of course, a stuffed bear.

At three in the morning someone knocked at the door. The racket we were making was more than enough to bring out the neighbors. But it wasn't the neighbors. Another Carole appeared. Same height, same age, same very skinny, not very innocent, adolescent allure. Same close-cropped blond hair.

This double entered, looked at us unsmilingly, and changed with a flick of the wrist from a skirt to jeans, probably bought in the same boys' department. So this was Beatrice. I assured her I'd already heard so much about her. She was, believe it or not, very happy to meet me. At a closer look, she no longer resembled Carole. Their common blondness and fragility was striking, but Beatrice had a closed, obstinate, and basically not very likeable face. As much as Carole tried hard to be liked, and to be liked precisely through her vulnerability, Beatrice was nothing but defensiveness and aggressively good manners. She picked up another guitar and eyed us as she played.

When Gilles and I left they were still playing, but Gilles had arranged to meet Carole the next afternoon.

It's nice, when you're tired and a little drunk, to find a big white bed and to sleep there with the boy you love. Besides, this was one of the things the little girl in question had been

singing to us about. We were happy and deeply in love. In love with us, in love with Carole, in love in a vague way, and in truth it was the right moment for that.

"Are you happy?" I asked Gilles.

He nodded yes with his head, and put an arm around my neck. Me too, I was happy.

"Do you like her?" I added.

I got the same yes. This was normal. Because if Gilles ever stopped liking the same girls I did, it would have introduced an element of separation between us.

2

A few days later, Gilles brought home one of Carole's paintings. I complimented it: a small, abstract composition, not ugly, better at least than anything by Francois-Joseph.

Gilles, on the contrary, thought it was one of the most mediocre things he'd ever seen. He's harsher than me when it comes to art. But since he's also clear-headed, I always come around to his opinion. I had to admit that what jumped out first in Carole's painting were its pleasantly stylish derivative qualities, not bold blunders of genius. But I rose to the absent girl's defense: novels and paintings follow whichever recipe is convenient at the moment. In any case, there's something to be said for cleverly using the clichés of one's time.

"But not in Carole's case," said Gilles. "She's unconscious. In the world she was brought up in, a girl paints if she doesn't feel like writing. And she paints exactly like that. Carole is totally incapable of cleverness. She doesn't even know how to live. She's lost in the simplest things, afraid of everything."

"Being lost is a skill like any other. And that's what she's good at."

"It works for her."

Gilles told me how the painting, regardless of its other qualities, was what had provoked the crisis between Beatrice and Carole—a crisis that was already brewing when we'd visited their room.

Beatrice loved this painting. She'd immediately insisted that Carole either keep it or give it to her instead. In a desperate reaction, she'd taken back her books and wasn't sleeping in the attic anymore. Then, suddenly, Francois-Joseph was mad at Carole too. So she didn't want to go back to her mother's place anymore, where Beatrice, on the other hand, was always hanging out now. Most likely talking a lot of shit to Francois-Joseph about Carole's immoral behavior.

I hadn't seen much of Gilles during this period. When I met him in the afternoon, he was usually tired from walking all night with Carole, between les Halles, Maubert and Monge. He rarely took her to Saint-Germain, I guess, or near Pigalle, not to mention Montparnasse, which we hated, or to any of the other parts of Paris where nights are lived like days and you always see the same people. I know Gilles's penchant for walking all night, how a café that's still open late becomes a precious port of call in streets where night people normally don't go. After two, rue Mouffetard is deserted. You have to go up to the Pantheon to find a bar, on rue Cujas. The next stop is by the Senate, then rue du Bac, if you have the good taste to bypass what we still call the Quarter. Here, I guess Carole told him the story of her life (as if she even had one yet). And then the sun starts to rise over Les Halles—it's a ritual.

Then, the next day, probably exhausted after all these wanderings, Gilles had to bring Carole over to the house. I was surprised, when she came in, at how satisfied she obviously was by all the recent dramas she'd caused, or suffered. I showed her nothing but cordiality, and she seemed relieved.

I already knew that chairs seemed abusively ceremonious to her, or at least that she would say so. So I invited her to sit on the carpet, and while we drank and she had her eye on me I brought out some plates of those Danish snacks that are like a whole dinner. She was visibly delighted by my style of hosting. I was making it clear that I always did things this way, and this gave her the chance to show off both her contempt for bourgeois dinners and the flexibility of her limbs. I've seen a lot of slender little girls, in my school days and since, with their kitten-like ways, and I wasn't impressed by such a perfect natural. But it was a pretty show. And me, dignified with my back against the bookshelf— because it's not my job to be cute—I kept my cool. Then I went and got the guitar.

"Play," I said.

"Gilles, do you want me to sing?"

Of course he did. And then we were all getting along perfectly and we talked a lot of nonsense. Carole explained how we were different from all the other people she knew.

"Who," I said, "… art students?"

"No," she defended herself half-heartedly. "First of all, you're only five years older than me. I have a lot of friends your age. And they aren't all idiots. But it's hard to explain.

You, you're at the same time much older and … younger. Especially Gilles."

"That's because you're in love with him."

"I know."

And no doubt embarrassed at having answered me so spontaneously, she quickly adjusted her attitude and strummed a chord. But I didn't say a word.

"Gilles," she tried to explain, "always feels things the way I feel them. Plus, he explains to me why."

"He's a thinking chameleon," I told her. "He thinks the things that are behind things. Keep singing, he likes it."

Carole came and lay down beside me. "I don't feel like it." And she told me about her last years in high school, and how she met Beatrice. I was letting her down by not saying anything against the latter.

I went to mix up another batch of what we were drinking. Half orange juice, half rum, a little ice. It had no name and she liked it a lot. Preparing this concoction, I thought she must be feeling confused, and that after all the cuteness she'd already treated us to, she was now on the verge of discouragement. On the other hand, what little courage she had left seemed to take up an enormous part of her existence. She was incapable of living alone. I liked making her sing. It amused me, the contrast between her generally vulnerable appearance and the insolence she affected as soon as she could take refuge in words she knew by heart. In this way, she could counteract her eagerness to please Gilles with an arrogance addressed to no one in particular—a hypothetical audience. Her lower lip

protruded, giving her a smug profile generally associated with the Hapsburgs in history and in photo novellas.

When I came back, they were quiet. "Be a good *jeune-fille* and serve us our drinks," I ordered.

"I am a *jeune-fille*," she said. Still smiling at Gilles, she brought me my drink, then sat with her knees under her chin and clasped her ankles in her hands.

The rum slowly numbed us.

"I'm beat," she explained. "I usually stay up late, but this is extreme. And I don't even paint anymore."

I saw her looking at her painting on the wall, pleased by its place among the others.

"And what about Gilles? When does he work?"

And turning to him:

"What are you working on, exactly? I have no idea."

"Reification," he answered.

"It's an important job," I added.

"Yes, it is," he said.

"I see," Carole observed with admiration. "Serious work, at a huge desk cluttered with thick books and papers."

"No," said Gilles. "I walk. Mainly I walk."

"I'm not sure I understand," she admitted. "But I used to walk around a lot too. I used to walk alone."

The alcohol was making her sad. She talked about time passing. Like all teenagers who aren't teenagers anymore, when they've read about and finally understood what being desirable is, she bitterly resented getting old, her changing state. She was young now, but before she was even younger.

"Don't worry," said Gilles. "We've discovered a method to preserve our adolescence, more or less. We'll only get old as a last resort. We'll let you in on our secret."

"Great," Carole smiled. "I'll never be sad."

"Yes," I said, "you have to be sad. Enormously. Otherwise you'll be old before you know it."

She joked:

"So, are you very sad?"

"Me? Horribly," said Gilles.

It happened to be true. Gilles often told the truth, when it came down to it.

"It's a strange way of being sad," she told him.

"The best."

I held out the carafe. Carole, sitting with Gilles, filled their two glasses and lay down on her back. She lit a cigarette, her hand was very unsteady. "Want one?" she said quietly, and turned toward him.

She smoked, torturing her lower lip. At the end of her bare foot she balanced a moccasin. Her blue sweater rose and fell with her breathing, as if she'd been running. A moment of silence.

There was no more orange juice. I swallowed straight rum. She sat up and did the same, then rested her head on Gilles's shoulder. He finished the bottle.

"What else is there?" He asked.

"Marc," I said, "and coffee for our true love."

"Don't be mean," she murmured.

Gilles's voice was affectionate:

"Geneviève is horrible. With everybody, and everybody loves her. Myself included."

We looked at each other and laughed. Carole recoiled a little and watched us—one, then the other. Finally she curled up on the carpet with her head on my knees.

Maybe it would have been more normal for her to get up and cause a scandal. Conjugal love rarely has a good reputation. Or, even more foolishly, she could have effaced herself in a friendly sacrifice to future memories; or, like a real woman, she could have started one of those fights that, in books, end with melancholic reflections on the permanence of received ideas and nostalgia for forbidden intimacies. It was not a new situation.

She moved her head around to make herself more comfortable. She had nothing on under her sweater. Supporting her, I felt her warm body under my fingers. I pushed her hair back behind her ears and leaned down to breathe in her lavender smell. She smiled carefully. I squeezed her gently. She rose unconsciously and found herself leaning even closer against me. She was tense. Her airy presence immobilized the room around us. One word would have upset the balance. In the end she let herself go in my arms and fell asleep.

I don't know how much time passed like this. Gilles gave me a sign to not wake her, which was the last thing I had in mind. When she moved again she was refreshed. She looked at us and Gilles told her it was time for bed.

"Not here," she said. "I absolutely have to be home at ten. I should go now."

Gilles got up, helped Carole to her feet and took his keys. Then he asked me to come too. I poured myself one last glass of marc. Carole was following me with her eyes.

"No," I said. "I'm too tired to go out."

When they'd left, I opened a window to clear the smoke and stayed a long time leaning on my elbows, not drinking. The night, very beautiful, was almost over. Soon it would be summer. When I felt they'd arrived safely, I went to bed and fell straight to sleep.

3

I woke up late, with a feeling of well-being. Without moving, I went over the events of last night, one by one, taking pleasure in their reconstruction and in the prognosis they suggested. To each gesture I lent a precise meaning, whose distant consequences deduced themselves. Finishing this game, I realized it was too late to go to work. Because almost every day I work at an advertising agency.

Without getting up, I phoned in a believable excuse. This boosted my courage. Rid of the day's obligations, I put on pants and sandals. I drank yesterday's cold tea. It tasted like Gauloises. There was still some marc left and it was good. Joyfully, I went out.

With Gilles, I'd follow long itineraries, complicated and full of traps. Alone, after a coffee and a croissant at the first available counter, the streets—empty of workers by now—always lead me to the same parts of the city. Gilles knows how to reinvent Paris. For me, the Left Bank consists of a few café tables.

Pretending to read the evening newspaper, which devoted a lot of space to celebrity romances, I found a place in the

sun. The usual suspects came by and stopped at my table. I won a few drinks rolling dice, lost some too, and wasn't bored. When Judith showed up, I let her take my seat at the table. She bummed a cigarette and immediately excused herself. She's better at this game than I am.

"Come on," I told her, "let's have a drink somewhere else."

I love Judith. I knew her back when I was a fixture in this scene. Like so many others, she danced in basements and sang a little. Now, faithful friends like her allowed me to not come off as a tourist here. We shared a lot of memories.

Judith was wearing tight pink pants and a checked shirt. I could see she was already a little drunk. But it was no problem for her to be like this throughout the day, every day. She was never ridiculous. She filled me in on so-and-so and so-and-so.

"I saw Gilles," she told me.

"Me too," I joked. "Many times."

Judith, had been waiting for her coffee in a funny, miserable little restaurant on rue Gregoire-de-Tours where we sometimes met, when Gilles came in with a girl.

"And I'm afraid there's been a bit of a falling out between us," she told me.

This was hard to believe. True, Gilles ended a lot of relationships for stupid reasons. I've seen him be deliberately cruel. But for the few people whose way of being he really likes, his friendship is solid—through anything. Judith was one of these.

"He was with a little drip," she said. "Holding hands."

"I think I know who."

"English schoolgirl type. Flat-chested, like me. Startled-looking, and very blond."

"That's the one … pretty, anyway."

"Yes," she admitted. "Rather. A pretty body. But painfully sentimental. Dripping with cuteness."

Judith openly despises throbbing hearts, but other kinds of emotion she's extremely sensitized to. Only in these does she see the possibility of honest relationships, and the energy of her character makes her come across as more hunter than prey. She had spontaneously congratulated Carole, "Gilles must be a good lay." And she told Carole that, to tell the truth, she wouldn't know. That she thought about it all the time, but hadn't had the chance to find out yet.

"I can't believe you did that," I said.

And neither could Gilles. Carole had frozen on the spot, seeing that the joke wasn't so funny.

So Gilles tried to explain to her that Judith was naturally crude and everybody was used to it. No doubt she'd done her best to create chaos with Carole. I know her way of having fun. Her vocabulary can be disconcerting. But Gilles wasn't letting it go this time. He told Judith to fuck off and left with Carole.

Judith had a funny way of describing the episode, but it bothered her in a way she wasn't admitting. Outside of love, she is deeply modest.

I called the waiter to refill our drinks. He brought two Ricards. I poured in just enough water to change the color. Gilles never puts water.

"It's an idiotic drama," I said. "It doesn't mean anything. When people are in love, they don't act normally."

"That's for sure."

She remembered several, similarly strange cases, weighing and judging them in her disenchanted mind.

"You're great," I told her, leaving. "One of these days I'll be like you."

The afternoon was a void in front of me. By chance, a movie theater along the way was showing a western—old enough that its qualities couldn't be questioned. For a modest sum, I sat through floods in China; a conquering army's total victory over some hopelessly destitute terrorists in the jungle; a presidential inauguration and a football match. Then, after a Colgate smile, came the real movie, the lion roared on the screen, and in ninety minutes the cowboy managed to get his girl.

Coming out, I caught a bus heading toward Place Maubert. From there, I walked to the Contrescarpe. The cafés were crowded. They were mostly painters and Americans. Some Americans were painters, others dreamed of becoming painters. I knew almost all of them. Their girlfriends were beautiful, already tanned, and dressed in the expensive clothes they wear so well.

Beyond a subtle frontier those people never cross, I went down rue Mouffetard and entered a restaurant that Gilles and I had found recently. Workers eat very good, peasant-style cooking there.

Gilles was sitting in the back. I realized I wasn't hungry,

but that I knew I'd find him here. He kissed the tips of my fingers and I sat across from him. The owner brought me the napkin I write my name on every week with a pencil. It's what the regulars do.

Seeing Gilles and I meet, one can never tell if it's a date or an accident. We never say anything that would define it as the one or the other.

"What are we drinking?" I asked.

"Ricard."

"I don't like Ricard."

"Drink something else."

"I don't feel like something else."

I asked the owner for a Ricard and some stew, like Gilles.

"Where are you coming from?" he asked nicely.

With a vague motion of the hand, I let him know I hadn't been up to anything worth reporting.

"And you?"

"Me," said Gilles, "I'm in love."

"I know. You always are. Is it serious?"

"No, since I've met you, it never is," he said regretfully.

"Probably because the love of your life, as they say, is me."

"That's what I'm afraid of."

When I met Gilles three years ago, I realized quickly that he was far from the cool libertine most people took him for. His desires always contain as much passion as he can put into them, and it's this same state that he always pursued in various love stories that you'd be crazy to call unserious. The atmosphere he created everywhere had to with honest feelings and

a heightened consciousness of the tragically fleeting aspect of anything to do with love. Also, the intensity of the adventure was always an inverse function of its duration. Trouble and ruptures happened with Gilles before any valid reason appeared: afterwards, it was too late. I was an exception, I was immune.

"I think it's true," I said. "I really do. Why don't you torture your wife for a change? Instead of Carole."

"Torture?"

"Putting her through all this pain and passion. She's so nice, Carole. So blond. By the way, I'm passionate about you too."

"Yes," said Gilles, reticently, "she's very nice."

"That's what gives me hope. When you're finally worn out enough to have a relationship with someone, it won't be with someone nice."

"God," said Gilles, "who said anything about a relationship?"

"Then everything's okay," I said.

"That's right."

"And I'm your most trusted accomplice?"

"Yes," said Gilles, "in the next world."

"Your jokes aren't funny ..." I began.

I stopped, my face red. Gilles wasn't used to this coming from me. I'd always left feminine weakness to the others. I made an effort to find my way back to the well-ordered world where I was never unpleasant unless I meant to be. Never with Gilles.

"I think we've exhausted the subject," he said lifting his glass. I said I was exhausted too, and we didn't mention Carole again that night.

Life went smoothly on. Gilles disappeared and reappeared regularly. For the first time, perhaps, he wasn't sharing things with me. Carole, on the other hand, wanted to. With me, she was surprisingly trusting and interested, no problem. This naturally improved my opinion of her. Each time we were together, I gave into her charm. I wanted to protect her, even against Gilles. But outside of these moments, I only mentioned her with indifference, not wanting to grant her too much of an existence.

Then one night, I heard that Gilles was mad at Carole. I found him at home. He was reading. He looked unhappy.

"I'm bored," he announced.

"You broke up with Carole," I noted.

"Basically."

"Too bad," I said. "She was so pretty. Does she know why you're mad at her?"

"No. She has to figure it out."

"Gilles, you might start to give people the idea that you're a bad person."

Gilles said that the ones who had problems with that never got a chance to find out. This time, I could tell there

was something unnaturally affected in his detachment. I asked if he was hurt.

"Obviously," he answered. "I was getting caught up in this story. Something had to change. But, in the end, all we know is what we lose, not what we find."

His face was a mirror of pain. And for two days it got even worse.

Married life was getting me down. But I have no taste for pain. I told him so, and offered to ask Carole to come over and see us. She would be here in a second. Gilles refused loudly. He thought my idea was like a bad vaudeville act. I admitted it was stupid, and that nothing good could come of it. It would be better to see other people. I tried to drag him to Ole's, who was having a party in his studio that night. It was impossible to be sad at Ole's.

"Precisely," said Gilles, sinking in his armchair. "I would stand out."

A moment later he added that he was too sad to drink.

He went and messed up the library. One after the other, he pulled out at least ten books, which he stared at for a long time, as if doubting their possible interest or as if he'd forgotten how to read. He held them, then threw them down in a pile. This slowness was driving me mad. Finally he closed himself off in a crime novel. I picked up a book too, to regain my composure, and sat across from him. But I was wasting my time, and he paid no attention to my display of resentment. Soon I was asleep.

It was already late when the telephone rang. I answered. It was Carole, who asked in a dull voice if Gilles was there.

"Hi, Carole," I said. Gilles came running before I called him. I went back to my book: it was none of my business. I didn't understand their conversation; Carole talked a lot and Gilles answered in monosyllables. Mostly he was saying yes. When he was done, he came and told me she'd be over any minute.

"Did you make up?" I asked. "Was it just a misunderstanding?"

"I changed my mind," said Gilles. "I have the right. The well-known right to change one's mind and not pay attention to dark thoughts."

"Dark thoughts don't belong in a vaudeville. But come to think of it," I observed, "this is more like a fairy tale. They'll live happily ever after, and won't have children. And they'll change their minds all the time."

"That has nothing to do with us," said Gilles. "This is a particular case."

"You could have fooled me."

"We'll see."

"I don't see anything," I said. "Nothing. She's not even the prettiest girl we've known."

Gilles answered that my bad faith was obvious. That he never pretended to love pretty girls, but a certain type of beauty of which Carole was a perfectly successful example.

"Sure … the sad kind."

"Not sad, tired."

"What a curse, to have energy. People leave you alone."

"It's true," said Gilles. "Carole's a constant mess. She always needs someone there to take care of her."

"You, of course."

"Me, for now. We understand each other."

"Gilles, be serious. What do you have in common?"

"Flaws," he said. "We have the same flaws. She's the one who told me that, but she's right. You and I, though, we have qualities in common."

"That's not much."

"It's the most important thing," said Gilles. "Carole herself has no importance."

"That's fine. I'm going to Ole's."

"Do you blame me?" he asked.

I kissed him, letting him know that I didn't, and left right away because I didn't feel like crossing paths with Carole on the stairs.

4

Even through closed curtains we could hear the party from the street. The noise guided us to the door.

Inside it was packed. A jazz record mixed with voices and various noises. It was a pretty bad record, probably brought here by someone. People were dancing in groups, and so wound up you might have thought you were walking into a surprise party.

I got myself a drink and went looking for Ole. I found him in the kitchen with some other friends. They seemed to be in a really good mood. Ole had a violin, and was waving it around to underline an argument. As usual, he was talking about aesthetics. Seeing me come in, he began to play a triumphal tune.

"What a circus," I said.

"Tell me about it," said Ole. "Where did all these people come from?"

"I don't know a single one of them."

"Me neither, but they all seem to know each other. Next time I'll get a door person. With a helmet, and a strict door policy."

Actually, it was always like this at Ole's. He encouraged the invasion, and then was sorry about it. Ole played dumb.

"Right," I said. "A friend of mine's a boxer. He also writes novels. Next time I'll bring him along."

"And Gilles? Is he coming?"

"No," I said bitterly. "He's too drunk."

They hissed at me. Drunk was no excuse. Besides, Gilles was a good drunk. And me, I had a lot of catching up to do. Suddenly I felt friendly and nice. It was an excellent thing having friends to put drinks in your hand. I wished we could have talked seriously though. "Actually," I would have begun, "Gilles didn't come because he didn't feel like it." Then I would have asked them what I should do about him. Basically, they were all a lot more experienced than me. But in a different way.

I went back out into the studio. I circulated, my glass in my hand. A breathless boy asked me to dance. Luckily, I didn't know how to dance. He asked me whom I came here with. I said I came alone. He insisted, since I looked bored. Then he wanted me to meet all his friends. I slipped away, enjoying this feeling that I was still at home in my own apartment, but without showing it. I found a quiet corner. People stopped paying attention to me. They were happy to have found a place to have fun, since they were having fun. They were decent, young people, maybe even students.

Nothing remarkable about this scene, except the girl who was doing some fast dance moves in the center of the room. Graceful, with long straight hair which she swooshed around

at the right moment, but wearing a fancy dress that didn't really belong here. Also, a blond boy with his back to the door, handsome, and who you couldn't help looking at because he was so tall.

Anyway, my glass was empty so I went back to the kitchen. It was more fun in there. You shouldn't let yourself get in a bad mood. Then the door opened and the tall boy entered. Totally at ease, he sat down and began to listen to what we were saying. He seemed very relaxed.

I was a little afraid they would send him out, since he was obviously a stranger in this room. If he had spoken, I'm sure he would have been shut down immediately. Especially if he'd asked our permission to join us. But he was cool and nice, and nobody took the initiative. Later, when he slipped into the conversation, it was no problem.

Little by little the studio emptied out. Only our group stayed put. And more of us were showing up late from other parts of the city. Finally someone came in and introduced the boy, whose name was Bertrand. We squeezed together to make room. Bertrand sat next to me and put an arm around my shoulders. Anybody here could have done that and I wouldn't have paid it any mind. But an unknown arm doesn't feel the same; it bothered me. And I had no idea what it was supposed to mean, or if it was just an unthinking gesture. So I pretended not to notice, and I didn't dare move.

I wanted to turn my head and get a look at him. I found him really attractive. But I couldn't allow myself. The situation was ridiculous. I said my goodbyes and I got up ... to see.

This happened to trigger a mass exit. In the street, all hands shaken, the only ones left were those of us who lived within walking distance. Bertrand was still there.

We took our time. At each corner, someone else split off from the group. Bertrand and I were almost whispering: empty, late night sentences. I wasn't tired anymore. When we passed my street, I said nothing and followed along with the others. Eventually, Bertrand and I were alone.

I always wake up early in a strange bed. I looked at Bertrand, I wondered about him. There was a sort of easy grace in whatever he did. He didn't talk much. I watched this boy sleeping beside me. God, was he tall, and handsome.

I was surprised, during the night, when he'd told me he was only nineteen. I never would have imagined this kind of cool confidence could come so early to a person. But nineteen, after all, wasn't so far off. I remembered how stupid I was in my relations with other people then. In five years, I'd learned some things. And how would Bertrand be at my age? The number of girls, in dorms all over town, still arguing with their best friend, or questioning the reality of the sensed world—like well-educated *jeune-filles* do—destined to torture themselves over the boy I was with right now.

I felt like waking him up. But you're already at a disadvantage if you're conscious before the other, and see them sleeping there: you end up taking care of them. Better to keep sleeping … it helps to be lazy. So it was he who made the first

move and I who, disturbed from my sleep, tried to remember who he was.

Later, when I made it clear this story was over, he had a hard time understanding.

"Come on," I said, "You must have been in situations like this before. Let's just say you had your little adventure."

"Are you always like this?" he asked severely.

"Pretty much."

"On principle?"

I began to laugh. "Do I look like someone with principles? It's ethics, my love."

"But I really like you," he said.

"Likewise," I said sincerely.

"This adventure ... we could make it last. For as long as you like."

"It's never as good as the first time."

"That would depend," said Bertrand, "on who the people are."

"And how often have you experienced such a miracle?" I asked.

"Well," he answered modestly, "there was an English girl ..."

I made him tell me. One single English girl. I was impressed: other guys would have described a much more active past than that. I told him so. He took advantage of this edge, and since until now I'd been so much clumsier in words than I'd been in actions, I decided to rethink the question, and ended up admitting this wasn't just a little adventure, it was more of a romantic interlude.

"So how long do I get in a romantic interlude, according to your ethics?"

"Not too long, but definitely longer than a fling."

He seemed okay with this and asked me for my phone number.

"What should I say if your husband answers?"

"Say 'Hello, it's Bertrand.' In the meantime, I'll warn him that you exist."

"Exist romantically?"

"Of course."

He seemed okay with this too. I smiled.

"Now," I told him, "you have to leave."

He asked why. I explained how lazy I was, that I liked to watch other people doing things. And that I wanted to watch him getting up before me. To leave a hotel together is ugly, confusing. You never know which corner to leave a person on.

"Anyway," he answered, "I should get back home. If my parents start to worry, life gets even more complicated."

He dressed quickly, kissed me on the forehead, and disappeared.

As soon as he'd gone, I picked up the phone and called the apartment. It was eleven o'clock. Gilles was still there. He asked if there were still a lot of people at Ole's.

"No," I told him, "I ended up going home with someone."

"Someone decent, at least?" he inquired. Gilles scrutinizes everything I do.

"Very decent, my dear. A poet. Lives with his old parents, and some brothers and sisters. He takes himself for an

enfant terrible, and what's more, plans to write books that will still create shockwaves after he's dead and gone. He's very good looking."

"And you fell for him," exclaimed Gilles. "You've never been afraid of banality."

"I love you," I told him. "I only love you."

Now he was laughing. He wanted to know if I'd broken it off smoothly. No, such a charming, discreet, sensitive boy was not someone to break up with. That would be a waste. I had to see him again as soon as possible, and take advantage of introducing him to Gilles.

"And then," I added, "since he's a poet, he'll only pay attention to you and the affair will be over."

I was right. Bertrand made no mistakes, and Gilles liked him immediately. He was always welcome and became a regular at our place. Like a ghost, he appeared at the most unexpected hours,. Gilles spoke his language, and Bertrand was completely taken in. At this point, I lost a little importance.

"Admit it," I told him, "you have fun seducing people."

Gilles said no, it was just that Bertrand was so smart:

"We could make something of him, if we only knew what. You have good taste."

I was glad. I called Carole.

"What are you wearing?"

She was always around, always so sweet, and more and more blond because I washed her hair with a decolorizing

shampoo. I cut it too, leaving it long in front, and gave her a big white sweater, assuring her she looked hot in it. Now it was fun to take her out: all the boys checked her out. We wore the same suede jackets, and I had some fun introducing her as my sister.

She'd brought over her painting supplies, since the light was better at our place. Little by little, other objects appeared too, until her chaos was completely installed. This was how she invaded the room we'd already begun to call Carole's room.

That summer we took our vacation late. Nobody wanted to make the first move. Finally someone invited Gilles to Saint-Paul de Vence. We would take our time getting down there, making multiple detours along the way. When Carole realized Gilles was bringing her along, she couldn't hide her joy.

"Excellent," she said. "If we run out of money on the road, I'll play my guitar for tourists."

And suddenly she began trying on miniscule bikinis, offering to lend me one. Annoyed, I said I wasn't a Greek sculpture and that I preferred something more classic.

I warned Bertrand that we were leaving soon. He was surprised.

"But I love you," he said, "and I don't want to end it like this."

I realized that going away without him would mean breaking up, and that I didn't want that. On the other hand,

it seemed like the right moment. I said goodbye, sadly. In the fall, we'd both be busy with other things. Let's not exaggerate.

That's probably why the trip was so awful for me. My companions looked like imbeciles when they were having fun. I was constantly in a bad mood. We had three flat tires on the way.

II

Facts have hard heads.

V. I. LENIN

5

It was a small house with chalk-white walls and a roof of pink tiles. Suddenly feeling rustic, Carole wanted to paint the shutters green. We convinced her not to. I closed the shutters in my bedroom to make sure that I could produce a permanent shade: I hate the sun.

The first day we did nothing at all. Carole lay in the sun, I stayed in my room and finished the crime novel I hadn't had time to read on the road, and Gilles didn't come back from his walk until evening. When night fell I put on mascara, Carole changed into some really tight white pants, and the three of us went out drinking until late.

The next day, Carole woke me up with music, under my window with her guitar. Gilles was already up. We went down to the café from the night before and had lunch.

Carole couldn't wait to get a tan. Such a legitimate desire was impossible to argue with. So I put on my bathing suit too, covered myself in a sticky lotion, and we lay down side by side on the terrace. I would be fine letting my mind wander vaguely, the way it does when you lie in the sun, on your

back, and we had a slow, sleepy conversation about the fun things we might do on this trip. I could feel ants crawling up and down my legs. I couldn't manage to get rid of them; they must have been imaginary. A fly buzzed around my head. The sun was blinding me. I would have been better off wrapped in a sheet.

"I think I'm tan on the inside now," I said. And I went and hid in my room, really feeling like I was on vacation.

Gilles returned from the village. He'd made an exhaustive survey of all the local cafés. He'd found a nice one, and was coming back to get us.

"Let's get Carole before she burns up," he said.

As she was getting dressed, we paced outside her door. Time was passing.

At the bistrot in question, we found a squadron of friendly American sailors. Surrounded, we drank Ricard. Our territory shrank little by little. Clever Carole didn't let them know she understood English. Besides, her accent was shocking because she'd picked it up in Kent. And she couldn't help translating what she was overhearing, which was distressing. We were photographed like souvenirs. We surrendered our table.

Further up, it was less picturesque, therefore less crowded. But the Ricard service wasn't as good. Gilles and Carole complained about the American occupation.

"If you think the sailors are bad," said Gilles, "you should see their intellectuals."

We were waiting for the enemy to retreat; they would inevitably be gone with the last bus. From time to time, Gilles

insulted the invaders from the sidelines. Carole elaborated upon the theme, more vigorously. Gradually, a certain emptiness was produced. There was still the usual tourist crowd, but we went back to drink our victory glass. We deserved it, I remarked, after more than two hours of talking about nothing else.

Still on the same topic, we walked back to the house, and Carole and I competed in the kitchen. It was a mistake, each of us trying to outdo the other. It was a complete disaster.

The day was over and I started to feel restless. I had to find something fun to do. But Gilles said he was exhausted by the country air, and since communal life is made of compromises, everyone went to bed.

On the third day, we got up early and decided not to waste the daylight. We'd go swimming. Carole was dying to. I slept a little more and gave in. Anyway, it wasn't difficult. We loaded our bags with swimsuits and towels, I jumped behind the wheel, and we were happily on our way. The road was deserted. Carole undressed in the car, between Gilles and I, so as not to lose a minute. We almost hit a tree. Before I'd even parked, she was jumping out the door and running swiftly into the waves. By the time we'd caught up to her, she'd already accomplished several nautical feats. But my tan was darker, which annoyed her. It depends on the skin, I said.

Gilles and I lay in the sand and watched her frolic.

"I'm not such a beach person," I said, "but it's a great place to sleep."

"I don't know …" He was carefully dusting the sand off his legs.

"You're allergic to fresh air."

"Not at all. It gives me large ideas. I'd be fine here if it wasn't for all this disgusting sand."

"It's good sand."

"We need some trees," he sighed. "Lots of trees and shade."

"What about grass?"

"Yes. And the Tour Saint-Jacques … so we wouldn't feel so lonely."

Carole, dripping wet, was circling around us now.

"Get lost, starlets!"

"Carole," said Gilles, "as the little mermaid."

She worked herself between us, putting a freezing cold arm on my back. Sand flew. She was all breathless and fresh. She wished we'd go swimming with her.

"It's easier watching you," said Gilles.

Now that she had our attention again, she wandered off. I saw Gilles following her with his half-closed eyes. He was smiling with amusement.

"Too bad there aren't any photographers around," I said. "Our Carole is a scientist when it comes to posing on the beach."

"She's doing it for you, not me."

"That could be."

"You haven't noticed?"

"Yes. It's an invitation to join the Carole fan club. If both

of us were crawling after her, she'd be more important. She'd feel secure."

"Sometimes I think you're the one putting that idea in her head."

"Because I'm a bad person."

"This could have some advantages," Gilles insisted.

"You'd love that."

And after a short pause, getting up and heading for the water, I added:

"Anyway, I'm not about to lose my last bit of prestige over this.. Don't count on it."

Finally, dazed by the sun, we made our way back to Saint-Paul. I would have preferred to stay in my room, flat on my bed, but it was more polite to dine together in the village. We were too many to really go primitive. It was too difficult to not get along. In the evening I made Carole sing a little. But her fatigue was painful to watch, the sea had broken her voice, and she stumbled over the lyrics, which by now I knew better than she did. Her repertoire was not bottomless.

Gilles and I had done nothing so we weren't so beat. When she'd gone to her room, which she hardly ever used, we stayed up a long time playing chess. Then we wished each other an affectionate good night, and I stayed up reading until very late, not caring if I'd be tired the next day.

In the morning, I turned a deaf ear. I screamed through the door that I was still sleeping, and not to wake me up. They said they were going out walking for a couple of hours and they'd come back and find me for lunch.

Staring at the ceiling, I was oblivious to the hour. I tried to fall back asleep. Then I had the feeling it was getting late. Actually, it was four o'clock in the afternoon. I got dressed slowly, thinking that since I was alone I was free to do whatever I wanted: my first day of freedom. I made myself a sandwich and ate it by the record player. I was wondering where they'd gone to. I wished they'd gone far away, to Bordighera, for example, or to Pamplona for a few days. It was hard to relax knowing they could walk in at any moment.

I stayed in the house until evening. Several times I thought I heard them. It was either passersby or nothing at all. They showed up just as I'd begun to stop expecting them. Joyful, and with shining eyes, they jumped on me. For some reason they'd been having a lot of fun, I had no idea. I figured they were drunk.

"Oh," said Carole, "you wouldn't believe how far we walked. We didn't sit down once. We went everywhere."

"And without even leaving the village," added Gilles.

"What village?" said Carole.

This set off another laughing fit. Everything seemed funny to them. I'd never seen Gilles so simple-minded: he must be happy. I didn't want to show how inept I thought they were, so I went and fixed a quick dinner. I insisted that Carole eat. She couldn't swallow a thing.

"Geneviève is like my mother," she said, and burst out laughing.

There was some bitterness in this, the first sign of revolt.

"You're a couple of drunks, is all," was my surly reply.

The night was a drag. I couldn't manage to become infected by their crazy laughter. To be nice, Gilles offered to play another game of chess. After he'd won, I told him he should teach Carole. And suddenly they were inventing a new game, completely mad: the value of each piece was subjective and changing, decided by the player with each move. They screamed and yelled, trying to intimidate the adversary, giving out false information to subvert the other's strategy. I slipped off quietly to bed, with the annoying feeling of exhibiting a spite I didn't really feel.

The next day was a Sunday. I had already decided to be bored, and I was bored. This tourist village made me want asphalt, shop windows, red lights. I would have loved a subway. Skipping dinner, I took the car and left. I wanted to see a city and went to Nice, where I dashed into a movie theater. It was dark when I came out. A little disoriented, I sat down at an outside table. Then I walked, I entered a brasserie. I put some coins in the jukebox and played several games of pinball, as if I'd never played before: letting every tilt upset me. I was consciously enjoying myself. But the overly precise compliments that my solitude was beginning to encourage chased me out. I had to defend myself in the street too. I didn't look like someone who knew where she was going, which attracts attention. I had to take the road back to Saint-Paul. It was rather sad and discouraging. I slipped into my room without anyone seeing me.

Monday morning, when I went down to the café to meet the others for breakfast, Gilles passed me a letter. It was

Bertrand, modestly announcing his arrival. He had arranged to stay with some family in Cagnes. He wanted to see us. I was so happy that I let it show.

6

Bertrand showed up in the afternoon, and we celebrated his arrival like castaways on a desert island. Carole and Gilles were happy because they both liked him a lot and because, not having seen him for two or three weeks, he seemed to be reappearing from an already vanished past. When he showed up I blushed instantly. I was the least cordial.

So our tour of the countryside began all over again with Bertrand. We took a new interest in everything that had already begun to bore us. Time passed easily. Gilles and Carole drank a lot. Bertrand filled us in. He was staying in Cagnes with friends, a brother and sister. The brother had a boat and nobody ever saw him. Hélène was naturally melancholic, and had received Bertrand with the same permanent dignity with which she'd always received him at her apartment on rue de Lille. She'd always supervised his choice of neckties, but here he wasn't wearing one. Once upon a time, Bertrand was a college student in love with her. Hélène was already an elegant woman now, dazzlingly self-assured. He felt stupid telling her this: she thought he sounded childish. However, since

they were no longer in the presence of professors, she let herself consider him anew, even encouraged him with his writing. Hélène had read all the great authors, but also all her friends' manuscripts, and she often gave them advice. She had a position in the literary world and knew all the right people.

Bertrand described this relationship with a feigned simplicity, in his cool way. He was funny, and we were a good audience that day. To conclude, he invited us all to have a drink with his hostess. Gilles explained confusedly that we weren't nice people except when we made a deliberate effort, and he doubted if we were capable of any friendliness today. Bertrand assured us that Hélène would be delighted, since he'd told her all about us. He wanted to call her right away and announce our visit. So Carole pretended she wasn't presentable. Bertrand assured her otherwise. It seemed we were going. On the way down, Bertrand came close and gave me an imploring look. He squeezed my hand and my heart melted. He said he'd come down here to be with me again, and I didn't answer, since he could already see I was happy he was there.

When we finally left for Cagnes, in the middle of the night, everyone seemed pleased with the expedition. But it became more of an adventure five hundred meters down the road, where the countryside was so beautiful and silent that we had to pull over for a moment.

Carole got out and began running all over the place, more exuberant than usual and I had no idea why. We wanted

to get moving again. Gilles called her name, uselessly. She was lying under a tree, saying this was the perfect place for her and refusing to budge. I gave Gilles a desperate look, wanting his help. Bertrand said nothing and gave no sign of understanding.

"Of course," said Gilles, "it's a beautiful night and there's no better place than here. But since we've never stopped until now, there's no reason not to keep going. The next stop is this lady who doesn't know Carole but is waiting for her with a drink. Therefore, Carole must obey, immediately."

"No," said Carole, inert and resolved.

Gilles said he'd stay with her, just long enough to beat her a little, and they'd join us shortly. It was nicer to go by foot. Without commenting, Bertrand gave them the address and took my place behind the wheel. I leaned against him and was very much in love.

Hélène received me with delicacy, but with a little more interest than the moment demanded. She was a rather dry young woman, with precise features and studied gestures. Her voice was pleasant, whereas mine suddenly sounded raw and neglected.

I remembered what Bertrand had told me, that very day, about his former feelings for her. However ingeniously he'd made it seem otherwise, I guessed that his awkward advances had not left Hélène exactly indifferent. She seemed to be searching me for traces of our involvement. Bertrand slipped off and, from the distance, made a lot of noise with bottles and glasses. Now that he'd arranged this meeting, he no

longer seemed so sure of himself. He must have been afraid that Hélène wasn't projecting the still-fresh image of a young boy full of charm but buried in Latin classics.

In fact, it was me she was examining, like a curio, like an actress. I saw that I didn't match the description Bertrand must have given her. He didn't know me well enough to imagine me any other way than how I was with him.

"I imagined," she said, "that you'd be more ordinary."

Make no mistake, this was a compliment. No doubt she'd been expecting a love-struck girl, hanging on Bertrand's arm. I told her that couples are always a depressing spectacle. She had to agree, and she was the embarrassed one now. Then we came around to saying nice things to each other.

"You have a pretty syntax," she told me.

I didn't have to lie when I said how much I adored her voice. Voice and syntax, we were saying, those are the most important things. As for vocabulary, two hundred words, it seemed, were sufficient, a dozen or two of which were filthy. Bertrand returned with a mixture he considered a cocktail. He was indecently young in his summer clothes. Satisfied with his creation, he poured us each a little and drank the rest in one gulp.

After which, probably in an attempt to fill a silence he found threatening, Bertrand did his best to tell some funny anecdotes:

"The other day someone called my uncle, who has a gallery in the faubourg Saint-Honoré. 'Sir,' he says in a quavering voice, 'I paint as fast as Mathieu, with the colors

of Pignon, as thick as Fautrier, and with the spirituality of Manessier.' 'But sir,' my uncle says, 'anybody can do that.' 'Hear me out,' the voice answered, 'I guarantee that everyone will be talking about this. And as for our contract, I ask only half as much as Alechinsky.' 'But,' the uncle cried, 'I still don't see why ...' 'Because,' the voice protested, 'I'm a horse.'"

Hélène laughed prettily. Bertrand didn't hesitate to pile up more stale stories: the one about the sadist and the masochist, the one about that crazy person at UNESCO, the one about the chameleon who dies of exhaustion on a plaid blanket, the one about the publisher who didn't like publishing.

We agreed that last one was awful.

"I can tell you an even nastier one," said Hélène. Then it was mostly her doing the talking. Hélène's stories were true and concerned all her friends and acquaintances. They were much funnier.

A lot of time had passed. I went to the window. I said that Gilles and Carole wouldn't be coming.

So we would wait for them in the morning. Hélène proposed that I sleep over, there was an extra room. I accepted this pretense. We wished each other a very friendly good night.

Bertrand followed me right away. We fell into each other's arms. We were finding each other again. And surprise! We loved each other.

Unexpected things happened that night. In the morning, we hadn't slept at all. But I regained my lucidity. Bertrand

surrounded me with new attentions, protected me: our relationship had changed during the night. I was tempted to put some order into my ideas, but I gave up. For now, everything could stay as it was. I let myself go soft.

If only out of decency, we had to get up and eat. Bertrand took me down to the beach, where we collapsed again. An outstretched hand was enough not forget to each other in our sleep. Waking up in the blasting heat, we said our zombie goodbyes to Hélène. We stopped for a coffee before getting back on the road.

"A large cup for your wife too?" the local waitress asked him.

"Yes," said Bertrand proudly.

Then, on the road, he said without looking at me:

"This is fun. And if we weren't so careful with our words, I'd even say I was happy."

Which was touching.

Gilles and Carole were sitting on the terrace at the tabac. Carole had her guitar, Gilles was leaning toward her, they were harmonious and gay. Making room for us, Carole made no excuses for last night's behavior.

"You should have brought the famous Hélène," she said.

"True. We should have."

I was ill at ease. There were too many of us. But we were obviously missing Hélène.

"Okay then, we'll go get her," said Bertrand, whose only thought was prolonging our tête-à-tête.

So we were off again, so fast we forgot to pay.

Hélène, who was on principle bored by life, was always coming up to Saint-Paul with Bertrand. Her presence had a natural way of cementing our group, which would have split off into couples without her, and I was always happy to see her coming. Only Carole showed her a childish hostility, because of her pretty haircut and perfect nails. "A pretentious bitch," she said. Plus, snobbishly: "and old." But Gilles, on the other hand, found her disdain for all things sincere and rather moving. Hélène only used mean words out of respect for the laws of the conversation, but without going so far as to exit from her curious solitude. Gilles is always the first one to notice the beautiful soul in a pretty girl.

Bertrand, who while on vacation hadn't forgotten his desire to be a famous and respected poet, was hoping she'd help him get published one of these days. He made frequent allusions to his work. So much that, one evening when we were all five in Saint-Paul after a long, friendly and aimless day, he pulled a sheet of paper from his pocket, saying he'd read us a poem he'd written that very day and that he was happy about.

Carole, being herself a poetic object, loved poetry. She struck a wise and attentive pose, and opened her big eyes.

"Just not too loud, please," I asked him.

"Don't worry," he assured me, "I'm only thinking of you."

And he read on in a monotone for ten minutes, ending thus:

All hands to the protocol islands
 of distance and indifference
Beautiful, rolling carpets of oblivion
Beyond what once was real
One and indivisible
Naked dawn for hands, morning for mouth
An Antarctica scorched by love
The streets of your youth
are forever sad and beautiful
The endless streets the endless nights.

Bertrand shot a helpless glance all around, waiting for the verdict. It was unanimous:

"Bad!"

"Very bad!"

"An antique."

"You have to keep working," Hélène resumed, "and find a more personal style. It takes time."

"It's not worth it," I interrupted her, "These days, poets begin even younger. By the time they've grown up, it's already too late: they're outmoded."

"True," sighed Hélène.

"The only ones who had the right to write like that are all bald now," said Gilles.

"And the best ones died when they still had hair."

Hélène, Gilles and I had spoken very fast.

"Fine," said Betrand, "I'll kill myself."

"But," said Carole, who hadn't been following the

conversation, "I thought it was beautiful. I'm just not sure I understood everything."

"In this family," I explained to her, "that's another way of saying: 'The marquise went out at five o'clock.'"

"I should mention," added Bertrand in an even voice, "that my poem begins with a quotation from Gracian's *L'Homme de Cour*: *Tastes are formed in conversation, and one adopts the taste of others through association. Therefore, it's a great joy to have intercourse with people of excellent taste.*"

"After hearing such things, I think a drink is on order," I said.

I refilled all the glasses. The massacre had to end.

"Yes," said Gilles, "that's a beautiful phrase. You really should write something so you can use it as an epigraph."

This absolution *in extremis* made me happy. And then we got drunk and didn't speak about literature anymore. I was too sincerely attached to Bertrand to accept that he was ridiculous. But in front of Gilles it was difficult to defend him, I thought bitterly. There had never been any bad faith between us. I admired Gilles a lot. And loved him.

7

It was September already. Not one day passed when I wouldn't complete the circuit between Cagnes and Saint-Paul. I was getting used to this landscape, which was still untouched by autumn's approach. I was even beginning to find it beautiful.

I was alone that day. First I stopped by the café. They hadn't been in yet. I left the car there. When I entered the house I found Carole packing a bag. Gilles came in and told me that he had to go to Holland earlier than expected. I already knew he had to spend two or three weeks there.

I asked him if this thing was so urgent that they'd have to skip lunch.

"No," said Gilles, "we're leaving tomorrow. But Carole's so excited that she started packing right away."

"Fine," I said.

"We're taking the morning train."

I hesitated.

"Okay, because I'll need the car here."

Carole, leaning on a pile of sweaters, was already gone. She wasn't listening.

I didn't know what to do during these preparations, there was still a whole long afternoon in front of us. I preferred spending it in Cagnes, so I proposed that they come down with us, since it would be nice to celebrate their departure. I helped buckle the few suitcases they were bringing, and we left.

"I see," said Hélène when she saw the luggage, "The people of Saint-Paul were offended and now they've evicted you. I've been expecting this."

Gilles smiled.

"Stay in Cagnes. The view is charming."

"Holland's not bad." I said. "Canals everywhere …"

"What are you going to do there?" Hélène asked.

"A scandal," said Gilles.

"That goes without saying. But what else?"

"A real scandal," I said. "In a museum."

Bertrand intervened, very interested:

"Is that really why you're going?"

"Not exactly," I explained. "Some friends will do it. But in cases like these, Gilles usually shows up ahead of time to organize the thing."

"We all end up specializing in something," said Gilles.

"And do you always organize them?" insisted Bertrand.

"One well-planned scandal is worth two," I said.

"Will they talk about it in the papers?"

"In books, rather."

"Let's go have a drink," proposed Hélène.

"Or eat, if it's not too late."

Carole was either starving or thinking of Gilles.

We had to go almost to the top of Cagnes to find a restaurant that would still serve us a decent meal. Since we had the whole terrace to ourselves, we stayed a couple of hours drinking eau-de-vie. The waiter stacked up saucers to keep track of how much we drank.

"A charming custom, more and more rare in Paris," said Gilles.

"Anyhow, it's quite a stack," said Bertrand.

"That's what happens when you do all your drinking in one place."

Carole dragged us to the train station to verify the departure time. She handled every detail. After the station, Hélène took us to a crowded club she knew. It was hard on the eyes and on the ears.

Dinner led us back to Hélène's, carrying bottles.

"Do you have any saucers?" Gilles asked.

"Sure. And cups."

"I don't want to drink without them anymore."

So we collected all the saucers in the house and stacked them in the middle of the table with each drunk glass.

"No fair," said Carole, "these glasses are too big. We should put more saucers down for each one."

"We could use plates," Bertrand answered.

The stack rose quickly. After dinner, we carried it to the garden with care and continued our work.

"My contribution to the group effort is attracting too much attention," said Gilles. "I'm using up all the saucers."

It was true. We applauded him.

Naked under a linen shirt, Carole was shivering.

"We should make a hot drink for Carole," said Gilles.

"Carole," I said, "put on a sweater."

She said she couldn't because all her clothes were already packed. Hélène disappeared and came back with a beautiful knitted jumper.

"It's so pretty," Carole told her. "Is it yours, Hélène?"

"No, it belongs to my brother Renaud."

We'd seen so little of this brother that we'd started to doubt his existence, let alone that of his wardrobe. Hélène informed us that he was still out sailing with their friend Léda. Hadn't we ever heard Léda sing?

"In sleazy cabarets!" Bertrand yelled. "With her amazing accordion."

"No," Hélène corrected him. "In good clubs. The accordion is only for intimate shows."

"You're just being nice because she's in love with you," said Bertrand. "I can't stand her. She's a stupid cow."

"Alright," said Hélène. "But then so is Renaud: he finds her exciting."

"Haven't you noticed," Carole interrupted, "how we all have names like characters in a novel: Gilles and Bertrand; Renaud, Carole, Geneviève? It's really funny. Heroes have names like those."

"That's right," said Gilles. "We're all characters in a novel, haven't you noticed? You and I speak in dry little sentences. There's even something unfinished about us. And that's how

novels are. They don't give you everything. It's the rules of the game. And our lives are as predictable as a novel, too."

"I don't find you predictable," Carole answered him.

"Maybe I'm unpredictable for you," said Gilles, "but hardly for the spectator on the outside. We're very easy to read, my poor love."

"On bad days," I said, "Gilles is more like a character in a folk song: 'The devil made me stray from the one I love,', etc."

Bertrand accidentally knocked over the saucers and then we drank without control. I was the first to collapse. When I woke up the next morning, Gilles and Carole were already gone. Perfect Hélène had gotten up in time to help them to the station.

I didn't want Bertrand to come when I went to close up the house in Saint-Paul. Obviously we could have stayed there until our return to Paris, but I'd seen this house too much, and this village. I preferred living in Cagnes.

I let him think I had a lot of cleaning up to do. In reality, I was moving in slow motion, from room to room. A half-century of endless vacations had flowed through them. I'll never come back to the Côte d'Azur, I thought as I threw a half-smoked cigarette into the fireplace, which was already full of them. No matter what happens, next year I'll be some-where else. In Brittany, no doubt.

I closed the shutters. The ones in my room had never been opened. My room hadn't been very useful. I had lunch down at the bar and left an exaggerated tip, enough to write myself out of this scene once and for all. Then I went back

and gathered all my things pell-mell. Bertrand was waiting for me on the beach.

After that I slept a lot. On the beach. In a bed with Bertrand. Late in the morning.

"This life suits you perfectly," Hélène told me sweetly. "Each day you're more slim and tan. You're at the peak of your beauty."

"No," I answered. "Gilles and I, we aren't beautiful. But we seem intelligent, and people like that."

But I knew she was right.

I looked at myself in all the mirrors and always rediscovered myself there with a new pleasure. The sun and Bertrand had changed me a lot.

I told him that night.

"Bertrand," I said, "it seems you're good for my complexion. That's a compliment that goes a long way."

Bertrand turned his head on the sheet and looked at me fixedly. He pronounced a long and embarrassed sentence in order to tell me that I'd always lived a crazy life, and that this winter I'd be spending a lot less sleepless nights in bars.

Such concern scared me. I didn't like Bertrand broadcasting human feelings.

"I'll make love to you at my place," he added. "You'll never go out again."

I moved a little closer.

"Assuming I'll even want to see you."

Bertrand slowly turned red. First the face, then the ears and neck. He surrounded me in his embrace, pulling me

close, and explained with much intensity that we were going back to Paris, that I'd never leave him, that we'd always be happy together.

I reflected calmly before responding. It was my fault. I'd dragged this poor Bertrand into our strange story. His face above mine was very beautiful and moving. He was handsome, young, smooth to touch, and he wanted to live with me. I didn't want to cause him any pain.

I told him it wasn't possible.

"It's very possible," he answered.

"I'm not an orphan," I said. "How does Gilles fit into your plans?"

"I'm going to ask him for your hand."

"It will be no."

His face hardened. He became distant.

"Are you sleeping with me or with Gilles?"

"Often with Gilles. Most of the time it's Gilles."

"Gilles is in Holland."

"Nothing that I don't know."

He hesitated before hitting me below the belt.

"And Carole …" he began with a sly look.

"Carole's like you. The salt of the earth, a day of happiness."

"It's not true," said Bertrand who was losing control of himself. "Gilles loves Carole, and besides, you'll always have her between you. I've seen that for a long time."

I was silent for a moment.

"Didn't it ever occur to you," I said finally, "that maybe I want Carole too?"

"I don't believe it," he said dumbly.

Then added:

"They're in love and there's nothing you can do about it."

"How long it lasts depends on me."

"Prove it then, if that's what you believe."

"Sure. Right away. In Paris. As soon as we get back."

"Alright then," he said.

Upon this false foundation we came to terms again. Then he smiled, mumbled some words, and fell unhappily asleep.

I looked at him lovingly. We never make anything without breaking something. Bertrand didn't know that in this omelet he would be the egg.

III

A tragedy need not be filled with blood and corpses: it's enough that the action is grand, the actors are heroic, the passions stirred, and that everything is charged with that majestic sadness that creates all the pleasure of tragedy.

RACINE

8

Moving in the opposite direction now, I retraced the road I'd come down two months earlier with Carole and Gilles. Like before, I was traveling with two companions. But this time we admired the views along the way and stopped at teatime, following arrows and road signs to hidden inns. It was not the same trip.

Not that I was enjoying myself less. Bertrand's docility was calling for trouble. I was abominable with him, sweet or vicious for no reason. The truth is I was perplexed. He suffered the consequences.

My mood swings couldn't have escaped Hélène, but she never pretended to come to Bertrand's defense.

"Do you think," she asked me when he wasn't there, "that it'll last much longer between you and him?"

She had an almost conspiratorial smile. This was strange. I stared as if I'd never seen her before.

"No," I said. "Definitely not."

Finally it was night and we'd arrived. The dust and fatigue of the journey had made us ugly. We all needed a bath and

sleep. We separated quickly without making any plans for later. Once I was on my own, I wandered a bit. Every time I found myself here again, I realized how much I loved Paris. I could never pass a bridge without congratulating myself for having been born here, having lived here. I could never live anywhere else, I told myself. Curiously, this led my thoughts back to Gilles.

I went straight to bed. In the morning I ran a bath, my last of the summer.

I was having issues, as they say. Without going into a panic, I thought it over while scrubbing myself with a horsehair glove. I had to do something.

I brushed my hair like a heroine, like a woman who'd learned how to brush her hair from reading women's magazines, if she reads at all. The mirror was covered in mist. I couldn't see myself.

"Bertrand," I wrote with the tip of my finger.

These are the things we wrote on desktops at school. Problems were for the blackboard. But school days were over and nobody would see this composition.

Then I wrote "Carole."

I erased one, then the other, and was pleased by this equation. My image appeared, distorted in the water. I picked up the brush and gave myself a gracious smile. "Everything will work out," I said to my reflection, which agreed.

I stayed home. I waited. Bertrand called very early. He wasn't happy and he wanted to see me.

"Give me two or three days," I said bluntly into the receiver.

A murmur of surprise on the other end.

"Be nice," I repeated. "Call me in two or three days. I'm really busy, I swear."

That afternoon, it was Hélène who showed up. I asked her to have dinner with me the next evening. Naturally she imagined Bertrand would be joining us.

"Is his presence really necessary?" I asked. "We're not on vacation anymore. I thought it would be nice to receive you alone, and more formally now."

Formality displeased Hélène less than everything else. And I really needed to please her.

It was an effort demanding much skill, and I overdid myself. By the end of the day, the apartment was done up like a baroque cinema set. I added candles and folded the napkins into swans. The whole thing was a challenge to good taste, Hélène would respond to it.

She arrived as if to a blind date, carrying parade roses. I integrated them into my overall scheme, of which she approved.

At first we were a bit gloomy. It was obvious we had nothing to say to each other. But the artifice of the décor and the idea that we were alone enticed us to make an effort.

Our black dresses were almost identical. I took Hélène's voice and, in exchange, she adopted my thoughts. I had prepared a lover's meal for her. It was she who courted me.

"We're so pretty together," she said.

She didn't try to stop me when I kissed her. Her lips were dry and hot. We stayed there for a long time, breathing quietly, as if these were the only known gestures of love. We stared into each other's open eyes. It seemed I could never see enough of this face. Basically, I liked her. She kissed me and my ideas were rapid and clear the whole time. We were still staring at each other, like schoolboys who challenge the other to look away first. The staring contest continued, even when we were on different sides of the room. Our gaze hardened. Then she rested her head against me, in surrender. I let it happen.

"Come," she said.

I never saw a girl undress so fast.

Hélène had lost ten years and a lot of confidence. It was the first time I'd ever seen her hair down. It was really long. She had a tiny body, and I was proud that she was so pretty. She resembled a Romanesque Eve that she'd pointed out to me during the trip. Something about it had made her uneasy.

"It will show," she groaned. "I'll learn to be stone-faced and ambiguous."

I did my best to reassure her.

"It's an excess of virtue that makes you look like that."

I got up to pour two large drinks. She really needed reas-surance. When I came back she buried her shame and confusion in my shoulder. This was a very little girl.

"Geneviève," she asked, "did you already see this coming … before, in Saint-Paul?"

"From the first moment I saw you," I told her.

This wasn't as false as it may have sounded.

"Do you love me?"

"Well, no," I said in a way that belied my words. "It's the easiest way for me to break up with Bertrand."

"Why me?" asked Hélène, who was only saying stupid things now.

"Because I didn't want it to be Carole," I answered, pulling her closer.

"Stop making fun of me," she said. "What's going to happen to me now?"

"Adventures."

I smoothed her hair; I was nice, and her fears dissolved.

She thought she'd be sleeping over. But I drove her back home. I didn't want her to wake up in my place: the decorations would be embarrassing in the morning. Hélène would think so too. So I dropped her at her door.

"Sleep well," she said with a lot of feeling.

But once I was alone there was no question of this. I owed myself a good time. It wasn't so late that I couldn't still find some friends out, if I hit the right spots. Friends are the ones who always dock in the same ports.

But the first one was deserted. I crawled onto a bar stool and drank a vodka. Vodka goes well with a wintery perspective. Nothing else provokes such presentiments of falling snow except, for some, the communist seizure of the state.

In the second bar I found the whole gang. I told them I'd just come back from vacation. In the state they were in, I may

as well have been coming down from Mount Athos. I wouldn't have gotten a warmer welcome and it went straight to my heart, I loved them all. The drinks were on me. I even consoled one very drunk man who was sulking in the corner, in an obvious state of despair.

"It's because he and I are writing a detective novel," someone said. "We take turns writing the chapters."

"All my characters keep disappearing," the sulking one said. "He always kills them."

At four o'clock the group was starting to come undone. Some left, the others went out in search of an after-hour's bar. I went along too. I saw Judith in the distance, in a large pack of Americans. We gave each other a friendly wave over their heads.

When the sun came up I was speaking Yankee and playing a dice game that was even more complicated than bridge, and the subtleties of which I seemed to be mastering. I disappeared when my force abandoned me and threw myself fully clothed onto the bed.

The telephone pulled me out of a heavy sleep. Even before answering, I knew it was Bertrand. I looked at my watch: it was 3 o'clock in the afternoon. I was hungry.

I answered. It was him. He asked if he could see me: he was at the nearest café. The sooner we end this the better, I thought, and told him he could come up.

I put my head under the faucet and lit a cigarette. I felt my face wasn't very presentable. He was already ringing the bell. I was suddenly afraid at the thought of how unhappy he was about to be.

Entering, Bertrand surveyed the disorder, and my looks. He might have been offended if he weren't so upset. As usual, he took me by the neck to kiss me. I turned away, resolutely.

Bertrand sat down and waited for an explanation.

"All good things come to an end," I said, steadying my voice, "as you know."

"Geneviève," he asked me, "what have you done?"

He seemed really crushed, which gave me strength to follow through with the execution. In a few words, I reminded him that I was the woman who could only have one lover. One at a time. More than that would be vulgar, indecent even.

"Who was here yesterday?" he asked in a restrained voice.

"It was your friend Hélène," I said.

Bertrand got up with dignity, went calmly to the door. I wished he were already gone. It was no longer about him. The worst was yet to come. And now, thanks to Hélène, I was only a little bit sad about losing Bertrand. I still liked him. He was in distress and I knew it.

"You don't love anybody," he said, opening the door. "I don't know why you love Gilles."

Bertrand disappeared, I started to tidy up, emptied the ashtrays, dumped the flowers. Before the post office closed, I wanted to send Gilles and Carole an innocent, affectionate postcard.

9

Gilles came back Friday evening, without warning, as I was getting ready to go meet Hélène. I was supposed to have dinner with her, and on Saturday and Sunday we had a plan to go hang out with some friends of hers who lived near Rambouillet. "Come spend the weekend in the forest," she'd said to me.

So I was putting on my makeup when, eyeliner in hand, I jumped into the arms of Gilles. He sat on a stool and watched me finish up. He didn't seem like someone who'd just been on a train; he told me he'd arrived the day before.

He went to pour himself a drink. While he did this, I finished getting dressed.

"Me too," I said when I came back to him.

Gilles handed me a glass and asked me where I was going.

"Dinner with Hélène."

"And Bertrand?"

"No," I said. "That's finished. Hélène is the new Bertrand."

"Is she as good?" Gilles asked, smiling.

"Better. Newer."

"Well alright," said Gilles with admiration. "Good thinking."

I went and sat at his feet, resting my head on his knees. He caressed me a little.

"I'm happy to see you again," I said. "It's a pain being alone. I'm your audience, and you're mine."

I told him what had happened. I told him the whole story in a way that made me look good, and it was a long story since we drank a lot and kissed too. Gilles didn't speak about his trip.

"I really like Hélène," I kept repeating.

But I would have had to leave right away. I told him I didn't feel like dinner with her. I proposed that he take me out instead, and Gilles brought me to an Italian restaurant I didn't know.

The place was perfectly artificial. The décor was a hopeless pretense at local color, supported by photographic enlargements. Loud, sentimental music coming from every speaker isolated the tables and introduced an element of confusion between us, too.

"Pretty scenery for a misunderstanding," I said.

"We've never lacked scenery," he responded.

"Nor characters."

Gilles watched me over his glass.

"Well," I said, "I haven't, anyway …"

I smiled at him lovingly:

"And you didn't either, in the old days."

"In the old days," said Gilles softly. "In the old days?"

I ordered an enormous ice cream, declaring one more time how foul this restaurant was. Gilles answered that it

didn't matter, since neither of us were either aesthetes or dilettantes. I acquiesced.

"I should call Hélène," I said getting up.

"Tell her I love her too."

When I came back, I asked:

"Won't you congratulate me again?"

"Congratulations," said Gilles. "And what's the occasion, by the way? How shall I begin?"

"With Hélène," I said in an offended tone.

"But that's normal," said Gilles, "you're my student."

"Was."

"It's possible to be and to have been."

"No," I said. "Not for much longer. I'm graduating and getting my degree."

Gilles shot me a really mean look.

"That's what happens," I said, "when the student surpasses the master, who gets old."

"No gratitude," said Gilles.

"But you're the most seductive. In the long run, I do as you do, and it works for me. But you, you're beginning to change. If I followed your lead now, I'd no doubt grow attached to Hélène. And looking at her closely, she's much more beautiful than Carole."

"I like youth," said Gilles, sincerely. "But now I'll congratulate you: with Hélène, I like you. With Hélène, I like you even more than with Bertrand."

"I knew it. I did it for you. But that doesn't mean I want to start a family. I'm not becoming faithful, in short."

"Quantity really impresses you these days?"

"It was never about quantity," I said. "You know it."

Gilles laughed a little.

"What's going on inside this young head," he said. "I imagine the worst. Getting some thinking done while I was gone, for example."

"Yes," I said. "I think."

"Amazing."

"And I'm thinking nothing good."

"In that case," said Gilles, "no degree, no graduation."

"I won't ask you for anything without my lawyer present."

"What would become of you without me, poor thing," he said with tenderness.

"I would become dull," I said in a tired voice, "and more sentimental, probably. But I'll have some boyfriends, at least."

"And me, without you?" he said.

"Very comfortable, I imagine. We have a taste for another way of living, but right now you might be wanting to liberate yourself from that liberty. And this world offers plenty of good models for the faithful lover."

"What makes you think," he said, "that I'm a faithful lover?"

"What makes you think," I told him, "that I've left Bertrand?"

We laughed together, just like we used to.

"Let's take a walk," said Gilles. "I won't let you go so easily."

I followed him for a little while longer, assuring him for the time being that until I was much better informed, I still

loved and admired him with all my heart. When I arrived late in the night, Hélène, who'd been learning a thing or two about devotion, had not one word of reproach.

On Sunday evening I found an envelope tacked to my door. It was Carole, writing to say that she wanted to see me. She asked me to come immediately, and alone. "Alone" was underlined twice. She was waiting in the café across the street, and I hurried over.

She was curled up in the back, a newspaper lying flat on the table. She had her eyes on the door. I noticed how red they were. She'd been crying. I sat across from her and waited.

"Take me somewhere else," she said. "I've been sitting here forever and the waiter's looking at me like some strange animal."

I preferred not to bring her home, afraid that Gilles would show up. I guided her further down the street and sat her down in a discreet corner. I ordered two very hot rum punches; her swollen eyes vaguely recalled the miseries that come with a head cold, and cold remedies. I felt it would be more comforting to drink the same thing as her. She would be less alone in her suffering.

Carole was burning in silence, without lifting her head.

"What's the emergency?" I asked.

"I needed to see you," she said evasively.

I insisted:

"Is it serious?"

"It's because of Gilles," said Carole.

Obviously, it was serious.

"What did he do this time?"

She tried to smile, but lost it along the way.

"It's over," she said.

Then her face clouded over and she let herself go. Pell-mell, she told me that I knew him better than she did, and that he'd always assured her that I loved her a lot. That she called me in order to try to figure it out. That she didn't feel she was up to the task, that she was completely bewildered. That she should have seen it coming.

"He's right," I said. "I do love you."

"I believe you," said Carole. "I believe you more and more."

"Thank you," I said. "And what did you fight about?"

"Oh, there wasn't even a fight."

"So why is it over?"

"I don't know," she said in a voice full of dismay. "I really have no idea. He left without saying why."

I put my arm around her shoulders and stroked her head. I was really touched, and embarrassed: all this sadness on display!

"He's like that, you knew it."

"Did he tell you anything?" she asked.

"No, he's said nothing to me. But you know how he is. A fight wouldn't be so serious, but when he takes off like that for no reason, he's not coming back. He always gets bored,

with everything. It's so puerile. It's part of his charm, I suppose. In any case, it's not your fault."

"He was the same with everyone, wasn't he?" Carole reminded herself, crushed.

"Yes," I said, "with everyone." But I added:

"But you were different. He preferred you. I never would have imagined this. Not so fast anyway."

"Me neither. Basically, I couldn't believe it. I've never understood what I was supposed to do."

I kissed her on the head.

"Go to the movies."

"What would you do, if you were me?" she asked innocently.

Naturally, I didn't answer. By force of habit, I asked the waiter to bring two more drinks. As Carole drank hers, I had the impression she was about to burst into tears. I took charge and hurried her into a taxi. She left me, saying that I was nice, that she knew she could put her trust in me. At that moment, she certainly thought so. I went home alone, exhausted. I don't like sad spectacles; they move me. I like happy people, without dramas.

Gilles appeared the day after the next. It was morning and I was on my way out to work. He looked like someone coming from very far away, and in a sad state. He said hello. He walked through the apartment and opened the window wide. He leaned against the rail and contemplated the street, where

nothing was happening. After a moment, I went to him and helped him take off his coat. He submitted.

I asked him where he'd been. He knew it was in the suburbs somewhere, but couldn't remember exactly. After some thought, he said it wasn't Aubervilliers, but some place like it. He wanted to go right to sleep.

Armed with these details, my mind was at rest. Cheerfully, I told him that he'd drunk too much. He asked what could possibly make me think that.

10

Hélène, who was well schooled in the arts of charm, was naturally a bore. Deprived of the obligations that until now had structured her days, she didn't know how to manage. She was not good at love. Or at any other way of spending her time. We certainly did Hélène wrong, but how could we ever know in which ways?

Gilles and I took her out a lot during these two or three weeks. Our trio was attractive from the outside but seriously lacked the internal cohesion that allows liaisons to last, or friendships to happen. Within these frontiers, nothing seemed real.

Unconscious of this disgrace, Hélène never found her place. In vain, she compensated for her awkwardness, and for who knows what feelings of guilt, with an excess of badly timed politenesses. In a Siberia of social events, this frozen river always required more hours of work, and the catastrophe came as no surprise. So much effort for so little profit.

Hélène was at the center of a group that came apart. Her presence gave it equilibrium, but later she became as useless

as a grand staircase in a ruined castle. Hélène didn't change, but a change in perspective had abolished her function.

We stopped seeing her for all these reasons, and for no reason ... out of sadness. Not having anything to reproach her for, I refused to confront her, preferring a bad fight on the telephone.

11

Toward the end of December, we received a letter from
Carole, saying:

"Dear Gilles, dear Geneviève,

"I'm back in Saint-Paul. My mother and François-Joseph
decided to send me to the countryside to relax. And there was
nothing I could say about it. So I decided to come back here,
where I have a very nice room on the ramparts. Winter doesn't
change this village. It just feels a little bit colder. There are less
people. I see nobody and I do nothing. But I'm not bored.
I've been doing a lot of thinking. I'm getting some painting
done too, and it's even a bit figurative now. I don't think you'd
like it but I don't know how to do anything else. Sometimes
one of my paintings seems like a good representation of what
I should have said but didn't know how to say, and then I'm
happy. As you see, it's always the same problems with me. I
wanted to read a lot of books, with you, but then I never
found the time. I don't know how to do it alone. There were
two huge storms. I am terrified by storms. I don't think I'll
ever meet anyone like you again. I don't know how you put

up with me. I hope Geneviève isn't mad at me. I dream about you all the time: we are walking in the forest, just before nightfall. We are holding hands in order not to lose each other. We are still children.

"I kiss you.

"Carole."

Two or three days later, I ran into Bertrand on rue des Écoles. He was in a uniform and looked, aside from this detail, more handsome than ever. He had just turned twenty years old.

It was late afternoon. We went into a bar. Bertrand was perfectly reserved and discreet. He expanded on the ignominies of military life, and how coming into contact with these had sparked a political conscience in him. And he filled me in on the misadventures of Hélène, who was now traveling around with the same singer-accordionist who'd been sailing all summer with her brother Renaud. He insisted that I take a letter that Hélène had written him because he thought Gilles would enjoy it. He himself didn't know how to answer it. I left him with the kind words one uses to reassure an undergraduate or a soldier who hasn't yet been discharged.

I went to meet Gilles in a café on the Boulevard Saint-Germain. He was alone.

"Anne is waiting for us on rue Git-le-Coeur, he said. Shall we have a drink here first?"

"Yes," I said. "I just saw Bertrand, dressed like a tin soldier, but all subversive. He also brought me some news from Hélène."

"Poor Hélène," said Gilles.

"He brought me a letter from her. You'll see, she still has heart and energy. As for Léda, she's the lesbian who was boating with her brother. The one they were saying mean things about in Cagnes."

"Oh right," said Gilles. "Hélène didn't like her."

And he read:

"My dear Bertrand,

"I really enjoyed your letter. So, you're a soldier now. I'm sorry for this most undeserved disgrace. Nothing about you suits this role. There's nothing as vulgar as being in the army, you know it perfectly well. People will forgive you many faults in life, even ridicules, but nothing as bad as this. As soon as you can, show them you have some mental disability, show them your poems, whatever. Don't become too much of a moron there. We love you too much to let this happen. And if someone has to disprove the popular axiom that all good poets die at the age of eighteen, it's you. Besides, don't pacifists die the same death as everyone else in this army? Decidedly, there's much to fear. And is this really the best way to publicize your unhappy state? As for me, I hesitate to tell our friends. I know you have a sense of humor. Still, wouldn't it be better to spread a rumor that you're in prison?

"That was Léda's idea. She really likes you a lot, which makes me happy because every day I become more attached to her truly extraordinary personality. We were in Scotland together. The country and the season perfectly suited this sort

of wildness that's in Léda and that's inseparable from her natural understanding of things, or her communion with landscapes, I should say.

"Here we are now in Megève. The other day Léda caused a scandal in more ways than one, but mainly by pouring a magnum of champagne on the Peruvian Ambassador. They're still talking about it. I really missed you that night. I know your taste for cocktails and everything that comes with them.

"As you can imagine, I've heard nothing form Geneviève or Gilles. Anyhow, why get involved with their machinations? They're not worth it. These are damaged people, a species that's spreading everywhere, it's true. They take advantage with their intelligent appearance, in the same way that richer people use money. But is there anything behind the gross contradictions of their lives? Nothing but an ocean of bad taste. I don't even blame them for being drunks, which is obviously the case if you think about it. What I despise and regret is their incurable frivolity. I hear they've been going around a lot with a young Japanese woman, whom they obviously share.

"Believe me, Bertrand, there are other values. I seriously hope you will not see these people anymore. Besides, they aren't happy.

"You must come see us as soon as you can. I want you to meet Léda now, since you never really got to know her before.

"Your friend,

"Helene."

We laughed a lot as we read this. Especially at the end.

"Unbelievable," said Gilles.

"And yet we have no imagination," I answered.

Gilles called the waiter.

"Shall we go?" he said. "I think we're late."

REENA SPAULINGS FINE ART
371 GRAND STREET L.E.S.
spaulings@yahoo.com

FEBRUARY\\\\\\\04

DADDY
STAB FRENZY & INSTITUTE OF CIVIL
DISOBEDIENCE
VINYL
ANTEK WALCZAK (PARIS)
AGATHE SNOW WINDOW SHOW
KOETHER VS. RICHTER LIVE
SPECTACLE
\\\\\\\\\
MUSIC
WINE
NUDITY

Afterword by Odile Passot

PORTRAIT OF GUY DEBORD AS A YOUNG LIBERTINE

> *What need is there to "make a portrait" of me? Did I not,*
> *in my writings, create the best portrait possible, assuming*
> *such a portrait were even the slightest bit necessary?*
> — Guy Debord, *This bad reputation...*

The Man Behind the Mask

With the publication of his *Memoirs* in 1959, Guy Debord
began, insistently, to paint his own portrait, which he
retouched again and again in the years that followed. Debord
gave much of his work an autobiographical dimension, inter-
mingling in this way objectivity and subjectivity, theory and
practice. Despite his desire for transparency, however, Debord
composed his texts according to a secret code, which must be
broken in order to understand what he really means. He cares
little whether the common reader understands: "Having,
then, to take account of readers who are both attentive and

diversely influential," he writes in *Commentary on the Society of the Spectacle*, "I obviously cannot speak in complete freedom. Above all, I must take care not to give too much information to just anybody" (1). Debord has, in fact, covered his tracks, so that only those who take the trouble to crack the code will understand his work. Despite the familiar faces in his films, his winks and private jokes, Debord gives little of himself away. He proceeds by allusions, while his real life remains hidden, obscure. In *In girum imus nocte et consumimur igni*, he lingers on the great episodes of his life (the Lettrist epic, May '68, etc.), but it is not always possible to reconstitute the chain of events without the key to his particular codes.[1] Unless done by one who knew him personally, any portrait of Debord that goes beyond what he himself made public will be at best speculation, and at worst sleight-of-hand. To understand the multiple self-portraits he left behind, we must turn to those who knew Debord, and recorded their own images of him.

During his lifetime, Debord was the subject of numerous accounts. Gérard Guégan depicted him in his 1975 novel *The Irregulars* as a character named Antoine Peyrot. Guégan had little love for Debord, and used Peyrot to settle the score between them.[2] Maurice Rajsfus dedicated the eighth chapter of his memoirs to a description of Saint-Germain-des-Prés between 1950 and 1954, just at the time of the Lettrist International. He met Debord there, and provides invaluable information not only on the revolutionary youth of the era, but on the screening of the first Lettrist films, including the

famous showing of *Hurlements en faveur de Sade* on October 13th, 1952 (Rajsfus 1992).

Since Debord's death, tongues have loosened, and accounts of Debord have become more frequent. Gérard Berréby conducted a series of interviews with Jean-Michel Mension, who took part in the Lettrists' escapades around 1953. The interviews give us a better understanding of the importance of the Lettrist movement in the development of Debord's ideas (Mension 1998). No doubt other accounts will appear in the near future.

To these various eyewitnesses must be added Debord's two wives, Michèle Bernstein and, later, Alice Becker-Ho. The latter has, for the moment, published only a short collection of poems, in which she mourns the suicide of her husband (Becker-Ho 1998). Bernstein, on the other hand, published two novels, *Tous les chevaux du roi* in 1960 and *La Nuit* in 1961, which are *romans à clef* of her life with Debord. I would like to study these two texts for the light they shed on Debord's life and intellectual sensibility. Of course, we must proceed cautiously, not only because they present themselves as works of fiction, but also because their author herself tends to minimize their importance. For several reasons, however, they deserve an attentive reading, which they have not yet received. Rather than taking the novels as works purely of the imagination, I consider them as "autofictions." This term, coined by Serge Doubrovsky, refers to a genre of literature in which the author presents aspects of his real life to the public in a distilled and reworked form. Autofiction is

neither a diary nor pure fiction, but an intermediate genre, with rules of its own. Michèle Bernstein does not tell all, nor does she call her characters by their real names, but she plants clues that identify them. The adventures she recounts have verisimilitude, and their truth has in fact never been called into question. For this reason, Bernstein's two texts seem essential to any understanding of Debord and the Situationist movement.

Dangerous Liaisons: Laclos meets the SI

Bernstein's novels, *Tous les chevaux du roi* and *La Nuit* have generally been poorly received by critics. Gérard Guégan is hardly kind to the former:

> In this novel by Michèle Bernstein, at the time Guy Debord's companion, the main characters—Gilles, Carole and Geneviève—labor never to grow old except "as a last resort." Closer to *Les Tricheurs* than to *A bout de souffle*, *Tous les chevaux du roi* published on August 30, 1960, has not convinced Ariane to read the Situationists. She couldn't get past page 65 ... Gilles is a grotesque of Debord, and Geneviève a screen for Michèle Bernstein, currently a literary chronicler at *Libération*. But novels *à clef* are worth less than novels without locks. (*Un cavalier* 81–2)

Shigenobu Gonzalvez cites both texts in his bibliography of Debord, but pays them little attention. He writes,

The first novel by Debord's former wife depicts the every-day life and loves of a "modern" young couple, as they used to be called. One recognizes Bernstein and Debord in the guise of the protagonists. There is no direct reference to their Situationist activity, only a reference to a trip to Amsterdam to organize a scandal. (Gonzalvez 130–1)

Of the second novel, Gonzalvez says only that "Bernstein repeats exactly the plot of *Tous les chevaux du roi*, which she structures in the manner of the authors of the *nouveau roman*"(131).

Michèle Bernstein has hardly helped her readers to take the two texts seriously. In a 1983 interview with Greil Marcus, she practically dismisses them as jokes.[3] Without taking her remarks quite at face value, Marcus, too, minimizes the novels' importance, noting that neither one was mentioned in any Situationist publication. Marcus recounts a legend according to which Bernstein's books were intended only to put money in the Situationist International's coffers at a moment when the movement lacked the funds to pay its printers:

"Michèle must write a novel," Debord said. "I cannot write a novel," she said. "I have no imagination." "Anyone can write art," Debord said. "But Situationists cannot practice a dead art," Bernstein said, "and the novel is dead if anything is." "There is always *détournement*," Debord said. (Marcus 422)

Convinced by this argument, the story goes, Bernstein went to work, attempting to manufacture a best-seller according to proven recipes and the public's expectations. Roger Vadim had just made a "scandalous" film adaptation of *Les Liaisons Dangereuses*, with Gérard Philipe and Jeanne Moreau; Bernstein in turn parodied Laclos's novel, in the hope of meeting a comparable success. Thus *Tous les chevaux du roi* was born. The novel sold well enough that the publisher commissioned a second; Bernstein responded immediately with *La Nuit*.[4] So, at least, the legend goes. It has every semblance of truth, and is, moreover, so widespread in the Situationist milieu that no one has displayed the slightest desire to read the two works with any attention, let alone to study them seriously.

This first novel was firmly, although discreetly, under the influence of the SI, of which Bernstein was one of the chief members at the time. Its epigram admits this influence eloquently: "This mixture of blue scarves, ladies, cuirasses, violins in the room and trumpets in the courtyard, offered a spectacle seen more often in novels than elsewhere." This quote from Cardinal de Retz had previously appeared twice in Situationist publications, once in no. 2 of the *SI* review, and once in Debord's *Memoirs*, both of which appeared in 1958.[5]

The epigram of the novel's third part is also drawn from the stock of Situationist quotations. It is taken from the Preface to Racine's *Bérénice*: "A tragedy need not be filled with blood and corpses: it's enough that the action is grand, the actors are heroic, the passions stirred, and that everything is

charged with that majestic sadness that creates all the plea-
sure of tragedy."(376). These lines appeared previously in
Potlach, no. 26, "Eulogy for Diverted Prose," without attri-
bution, as was the rule with *détournements* (233). Recall that
Racine's tragedy is about the split between the lovers Titus
and Bérénice, obliged to separate for reasons of state. Other
signs place Bernstein's volume discreetly under the Situa-
tionist aegis, beginning with the dedication "for Guy." Our
purpose here is not to catalogue these signs, however, but to
show the direct relation between Bernstein's novel and the
Situationist sensibility of the time.

As I will demonstrate, although the Situationists
denounced the spectacle, they were themselves avid specta-
tors, especially of certain films, whose role in their personal
mythology is reflected in Bernstein's novels.

All the King's Horses

Tous les chevaux du roi is divided classically into three parts,
like Debord's *Memoirs*. It recounts episodes from the lives of
Gilles and Geneviève, a couple of Parisian intellectuals who
move in the avant-garde literary and intellectual circles of the
era. The story takes place in the spring of 1957. It is told by
Geneviève, spokeswoman for the author. At the opening of a
show of recent paintings by François-Joseph in a Latin Quar-
ter gallery, the painter's wife invites Gilles and Geneviève to
dinner. Over the course of the dinner, surrounded by artists
(doubtless Surrealists) who "paraded out ... all the ideas from

thirty years ago" (22), Gilles and Geneviève meet Carole, the painter's stepdaughter. Carole, twenty years old, is herself a painter, with an androgynous charm neither Gilles nor Geneviève can resist: "On her feet she seemed so small and incredibly slight. The mussed bangs, the short blond hair, dressed like a model child in a white crewneck and a blue sweater, she obviously didn't look her age" (23).

After the meal, Gilles and Geneviève take Carole home in a taxi. She lives in a maid's room in a bourgeois apartment, in the posh sixteenth *arrondissement*. Carole invites the couple up to her room, where she enchants them by singing traditional French songs, accompanying herself on the guitar. "Carole sang well, and classic songs: girls who are beautiful at fifteen, their boyfriends gone to war. Girls who lose a golden ring by the riverside, lamenting the passing of the seasons, who never give up on love. Girls who go into the woods, girls one misses later, at sea, and the voyage will never end" (25).[6] The arrival of Carole's friend Béatrice casts a pall on the little gathering. Gilles and Geneviève hurry home, eager to know Carole better: "We were happy and deeply in love. In love with us, in love with Carole, in love in a vague way, and in truth it was the right moment for that" (27).

In the following days, the couple see Carole again. Gilles in particular takes her on long walks at night, and seduces her by making her see the city in a new light: "Gilles knows how to reinvent Paris" (37). These nighttime walks must be understood as real *dérives* between Les Halles, Maubert and the Place Monge. They are the occasion for the exchange of

secrets and for chance encounters in cafés, which are the stops on this initiatory voyage. The *dérives* bring about a spiritual change in Carole—*dérive* being a *psychogeographical* experience, that is, an experience in which the psychological dimension is inseparable from the apprehension of space. When Gilles brings one of Carole's paintings home, the gift provokes a falling out between Carole and Béatrice. Henceforth Carole acquires a separate existence; she gives her life its own particular meaning.

Gilles and Carole become lovers. They spend a good deal of time together; they quarrel and they make up. Without admitting that the affair hurts her, Geneviève distances herself from her husband. While visiting her friend Ole, she meets a very young man, Bertrand, whom, that very night, she takes as a lover. When summer comes, Gilles, Geneviève, and Carole go south to Saint-Paul de Vence. Bertrand, although he's beginning to tire of Geneviève, arranges to visit Hélène, a family friend who lives near Saint-Paul. At summer's end, Gilles and Carole travel to Holland, where Gilles is supposed to make "a scandal" (78). Geneviève returns to Paris with Bertrand and Hélène. She invites Hélène to her apartment, and begins an affair with her. Geneviève tells Bertrand about it the next day, effectively breaking things off with him. When Gilles returns from Holland, she tells him, too, about Hélène. The couple make up in the end, Gilles giving up Carole and Geneviève, Hélène. After their various affairs, Gilles and Geneviève find themselves together again, more strongly bound to each other than ever before.

This somewhat dry synopsis doesn't really do justice to Bernstein's light, ironic, and charming novel. Gilles is immediately recognizable as Debord. When Carole asks, "What are you interested in, really?" Gilles answers, "Reification." The girl then says, "Serious work, at a huge desk cluttered with thick books and papers." "No," Gilles replies, "I walk. Mainly I walk" (33).[7] The shadowy character of Ole is inspired by Asger Jorn (1914–1973), one of the founders of the SI, and, earlier, of the Cobra movement.[8] A close friend of Debord and Bernstein, he financed the *SI* review and the films Debord was making at the time.[9] Finally, we can see Bernstein herself in Geneviève, the narrator. Born in Paris in 1932, she was one of the founding members of the Lettrist International; her name appears in *Potlach* beginning with the third issue; she married Debord in 1954.

Even if the ideas dear to the SI at the time, like the *dérive*, *détournement*, and *séparation*, are treated lightly, Bernstein's novel nevertheless communicates the fundamental values of the movement, as they are presented in the first issues of the *SI* review. What's more, cultural references in the novel are numerous enough to give the characters some weight.[10] In addition to the allusions to traditional French songs and to surrealism and other movements, we find the universe of the eighteenth-century libertine novel. Geneviève is a Marquise de Merteuil, less cynical than the original, steeped in the work of Sagan and Beauvoir; Gilles is a Valmont with less respect for the mores of his time, who falls in love with a Cécile slightly less naïve than Laclos's model.

Cinematic Influences: A Tale of Two Gilles

The novel bears the clear imprint of Marcel Carné's 1942 film, *Les visiteurs du soir* (*The Devil's Envoys*). Based on a screenplay by Jacques Prévert and Pierre Laroche, the film takes place in 1485, and concerns two troubadours, Gilles and the androgynous Dominique, who seek shelter in a castle and are invited to participate in prenuptial festivities. What their host does not know is that Gilles and Dominique have been sent by the devil, to spread despair. Through their diabolical art and enchanting songs, they spread trouble and dissent. They carry a sort of plague, a romantic passion that scoffs at authority, convention, and social values and escapes the control of the devil himself. Dominique is sexual ambiguity incarnate, now a page and now a young woman; she is also a damned woman, a sort of Laclosian Madame de Merteuil, who uses people for her own dark ends. Her partner Gilles calls into question traditional notions of love. In the course of a hunting expedition, he leads Anne, the bride-to-be, into a forest labyrinth, a metaphor for the loss of all points of reference. In the heart of the forest he takes her for the first time, forcing her to discover "true" love. After which he rejects her, less from indifference than in order to make her despair, as he had promised Satan. These elements in *Les Visiteurs du Soir* are reference points for Debord and Bernstein, who alluded to the film a number of times.[11] Debord is given the name Gilles in Bernstein's two novels. Further, a song from the film, "The devil takes us far from our fair maids," returns in *Tous les chevaux du roi*. The novels's Gilles is

both romantic troubadour and tempting devil. In Bernstein's universe, there is no transcendence, divine or diabolic; humans are subject to their own negativity, which they cultivate to destabilize their century's received truths. The film's Dominique and the novel's Geneviève also have a number of traits in common. Where the latter uses her sexual ambiguity to seduce Bertrand and Hélène, the former turns the heads of both the old Baron and his future son-in-law. Anne, the object of both troubadours' romantic assaults, possesses on the one hand the naïveté of a Cécile de Volanges, and on the other the passionate violence of the Présidente de Tourvel. In Prévert's scenario, she performs the same function as Carole in Bernstein's novels: she is part of a game whose real stakes she does not understand. Bernstein's novels don't simply allude to Carné's film; they model Gilles and Geneviève's behavior on the film, and, by implication, on the tradition of negativity in which the film is inscribed, even if the novels change the ending somewhat, with the "diabolic" couple making up, although at their victims' expense.

The numerous literary and cinematic references, once one recognizes their importance in the economy of the story, give Bernstein's novels weight and depth. Her characters sometimes become aware that their behavior has a novelistic or spectacular dimension: "We're all characters in a novel, haven't you noticed? You and I speak in dry little sentences. There's even something unfinished about us. And that's how novels are. They don't give you everything. It's the rules of the game. And our lives are as predictable as a novel, too" (80–81).

La Nuit: Laclos meets Robbe-Grillet

La Nuit, published in 1961, reuses the same characters, with the same names, and the same plot. Only the esthetic is different: this time it is inspired by the *nouveau roman* and is indebted to the two films Debord made at the time: *On the Passage of a Few Persons through a Rather Brief Period of Time*, and *Critique of Separation*. Further, the novel's epigraph, which places it under the aegis of Henri Lefebvre, clearly indicates theoretical preoccupations.

Bernstein mixes episodes told in the present, past, and future in a jumbled series of paragraphs, like clips of film arranged without regard for chronology. Without knowledge of the previous novel, the plot is nearly impossible to follow. The passages written in the present describe only a single episode, Gilles and Carole's seemingly endless walk through Paris on the night of April 22, 1957. Their stops in cafés and the buildings they look at are described in great detail, like a slow-motion sequence in a film. The night is important in that Gilles and Carole, who have only known each other for a few days, discover the intensity of their attraction to one another. They seal a silent pact, which will lead them to become lovers that very morning, in Carole's room. Although there is no narrator, the author "sees" Gilles and Carole's walk, and attributes to it an importance it did not have in the first novel. Their itinerary is presented as an initiation, a voyage into the labyrinth of the quarter, and ends with an exit, or rather with a return to civilization. In Bernstein's

novel, as in Debord's *In girum imus nocte*, night is opposed to day, and the Latin Quarter to the rest of the city, as negative to positive.[12] Over the course of this initiation, the relationship between Gilles and Carole is transformed: they have plunged together into the heart of the labyrinth, into the sleeping city, which the author presents as a sort of mysterious forest. They have, in effect, chosen a dangerous and unknown path:

"I'd like to be in a labyrinth with you," Carole says.
"We already are," says Gilles. (92)

The episodes told in the past deal with the events leading up to the night of April 22. They are concerned principally with the places where significant events took place: François-Joseph's gallery, his apartment, and Carole's room. Here, again, the author includes numerous details only alluded to in the earlier novel. Among other things, we learn that Carole and her step-father François-Joseph aren't as simple as they seemed. During their dinner, the artist, who has drunk a good deal, teases his stepdaughter insistently. "There was a sort of complicity between them in misunderstanding Carole knew for what deep reasons (no one is that young, nor *that* innocent), François-Joseph took such an interest in her, and, although by her spite she showed that she didn't want any part of it, still she encouraged it a little, admitted that it was there" (40).

The episode of songs in Carole's room is likewise presented in a new light. Carole is described as "a woman-child" (52); she sings at Gilles's request, to please him, thus reversing the

relation between Anne and Gilles in *Les Visiteurs du Soir* (where it is the latter who sings for the former's pleasure). Carole's repertoire includes Maurice Thiriet-style laments, taken from Carné's film (56–7). It is not simply the girl's musical talent that fascinates, but her sexual ambiguity, which moves Gilles and Geneviève to the point that they feel themselves immersed in the atmosphere of the film, in the festival Baron Hugues gave for his daughter's wedding. Thus one of their cult films bursts into their life, thanks to this girl, still practically a stranger: "Her charm was not in her song, but in the way Carole identified with her songs ... and her way of seeming a little girl—or a page—or more exactly, a girl with a boy's allure, singing, leaning back, and accompanying herself on the guitar" (71–2). As Carole identifies with her songs, Gilles and Geneviève identify with the intrigue (reworked in their imagination) of *Les Visiteurs du soir*.

When Carole's friend Béatrice appears, it is noted that "She was the same size as Carole, her hair of the same color, and done the same way, almost like a boy's" (66).[13] It's not until the middle of the novel that we discover that Carole and Béatrice are involved with each other romantically, ever since boarding school, a fact that their parents overlook, either because they don't see it or because it serves their purposes too well. Carole hints again and again at her lesbianism in Gilles's presence, but he never asks her "to explain herself clearly." Her affair with Gilles is an occasion for her to move from a homosexual to a heterosexual relationship, as she breaks with Béatrice once and for all.

If one reads the novel in a Situationist perspective, that night becomes a trip into the labyrinth: the streets of Paris have the magical properties of the forest in the Middle Ages, Gilles and Carole are two knights, or rather a knight and his page, who are initiated into the mysteries of life. As they leave the maze, Carole discovers that she has taken on the Situationists' way of seeing the world, beginning with the practice of the *dérive*, which consists not only in breaking up the utilitarian understanding of the world that underlies urban practice, but also in an openness to new encounters and unexpected events.[14] After this initiation, one imagines that Carole will master the complexity of the Situationist worldview. She will know how to distinguish between the Situationist movement and the pseudo-avant-garde personified by her stepfather. Gilles's love initiates her; it allows her to change her ideas, her values, her way of acting in the world.

The title, *La Nuit*, refers in part to the practices of the troubadours, whom Gilles mentions to Carole in the course of their wandering. He "confirms to her the importance of the theme of dawn in their work ... their horror of the day was a horror of the law, and the break of day, the break of separation" (81). Originally, when Gilles and Geneviève had visited Carole's room, *they* had been *Les Visiteurs du Soir*. But during Gilles's night wanderings with Carole, the plot of the film obsessively continues to work as an unconscious. This, at least, is what Geneviève imagines: that Carole has taken her place, that Carole now plays Dominique to Gilles. "Sad, lost children, Gilles and Dominique ride slowly down the rue

Cardinal-Lemoine. They are mounted on white horses, guitars strapped to their backs. A grand new castle awaits them, and it is the devil who sends them on their way" (49).

At one point in their travels, Gilles tells Carole, "There's something medieval about you. Your haircut, at least. Your sweater, like a coat of mail." "Like in the movies?" the girl replies (48–49). Nothing more is necessary for Carole to slip into the "obsessive myth" Gilles and Geneviève have wrought.

Given her skill with the guitar, she takes on the role of Dominique—or rather Gilles generously assigns it to her.[15]

A little farther on, Carole speaks her mind:

> "I remember ... the couple riding in *Les Visiteurs du Soir*, in the beginning, outside the castle, where their arrival will change everything.
> ... They arrived together. I think we're just the same. I could dress up as a boy, and pass myself off as your younger brother."
> "Yes," Gilles says, "but no one sent us."
> "That's not the point," Carole says. "We're still coming from far away, aren't we? And we could make a lot of trouble."
> "Surely," says Gilles. (98–99)

Here Carole becomes dangerous for Geneviève. She doesn't accept the role she's been given, the role of Cécile Volanges, of Anne, Baron Hugues's daughter. Carole wants Geneviève's place, a desire she justifies on the grounds that she looks somewhat like Gilles's wife, and can play an instrument.

In the course of their walk, Gilles seduces Carole, certainly; at the same time he treats her with a nonchalance that suggests that, for the moment, she is nothing for him but a small animal, or at best a doll: "It's Carole he kisses ... and caresses, carelessly, so that she won't protest, or even respond, like a statuette or a toy, no part of which is erotic, as its erotic properties have been diffused harmoniously through the whole" (68). In other words, Gilles reduces her to a "girl-object." On occasion, the author herself calls Carole a "beast" (95), an "animal" (135); that is, at once inferior, familiar, and domesticated. At their first meeting, didn't Carole show that "she likes to obey, to be given orders" (164)?

When he goes walking with her, Gilles likes to hold Carole by the neck: "He always rests one hand on her, at that moment on the nape of her neck, a gesture that gives Carole an air of complete obedience, as if she were an animal on a leash. She is just small enough for Gilles to find the gesture comfortable" (57–58).[16] When Gilles and Carole meet in a restaurant, at the start of their affair, Geneviève tries to reassure herself, evoking the fundamental confidence that ties her to her husband, and the necessity of not attaching too much importance to the girl.[17] Even as she minimizes the place occupied by Carole, who after all is not the first "other woman" in Gilles's life, Geneviève reminds her husband that he will have to break things off with Carole shortly, if he doesn't want to compromise the pact on which their marriage is founded (97–98). Geneviève is perfectly aware that she's manipulating her husband, trying to get him to put an end to an affair that injures her. But, too intent on

her own ends, she bungles it. Gilles breaks up with Carole, only
to resume his affair the first time she calls.

An "Open Marriage" and its Limits

In *La Nuit*, Geneviève appears as both more hurt by her
husband's infidelity and more cynical about her means of
bringing him back. The novel can be read as the description
of a betrayed woman who attempts to recover her husband
but is hampered by her own political and social beliefs.

Geneviève cannot use bourgeois means; she must invent
an original solution in order not to lower herself in the esteem
of the man she loves.

Gilles and Geneviève are non-conformist in their ideas,
their way of living, and their way of loving: "… Carole under-
stands that Geneviève sleeps with other men, and not without
telling Gilles about it" (47). Gilles seems to be a man of great
intelligence and vast culture, charming, original, and seduc-
tive. He demonstrates a gentleness (sometimes tinged with
mockery) in response to every challenge. He breaks friend-
ships off for no apparent reason, at least none known to the
friends concerned. His relation to Geneviève is founded not
so much on mutual attraction as on a shared conception of
life. In *La Nuit*, the author emphasizes more than once the
willfulness, even the control that the couple exert at once on
their own lives, and on the fate of those who come near
them, like Bertrand, Carole, or Hélène. It is, however, easy to
discern the bad faith of certain passages in the novel, in

particular those in which Geneviève explains her own feelings. She deceives herself as to the extent of her nonconformity. Even as she gives her husband free rein in his ideas as in his loves, she never ceases to scrutinize his every movement, the changes in his mood, the development of his feelings for Carole. She literally "hallucinates" the night of April 22, of such great importance for her, in that she risks losing the man she loves. She takes Bertrand as a lover to avoid being reduced to the bourgeois role of the cheated-on wife, incapable of holding onto her husband.

Even for those open to multiple experiences, some limits are not to be crossed. Even if one grants one's partner sexual freedom, freedom of affection—with all that it implies—constitutes a threat. This is a stumbling block for any sexual revolution, in 1960 as today. We can note another problem, which has to do with the gendered division of labor in everyday life. Gilles and Geneviève behave traditionally, in that he allows himself to be waited upon, while she takes on the greater part of the household work.[18] This reservation aside, Geneviève is indeed a nonconformist wife, free from the prejudices of her time: she welcomes Carole, attracted as she is to the girl. She even participates, mentally, in Carole's affair with Gilles, which she can experience only at a remove.

But once she feels genuinely threatened, Geneviève must find a way to defeat her rival. In so doing, she must take into account the tacit, liberal, even libertine conventions between herself and her husband. These conventions imply not only sexual freedom for both partners, but also a solidarity between

them, built of mutual trust and shared values.[19] But there is this new, unexpected element, Gilles's excessive love for Carole, which threatens to destabilize the "permanent" couple, Gilles and Geneviève. Carole's demands for love, her tricks and her lies have brought on the unforeseen, the uncontrollable. Gilles finds himself overcome by this girl, who is not satisfied with the secondary role assigned her by the script. He breaks with her, finally, on the day when she dares to ask him to account for himself—that is, when she behaves like a jealous and possessive mistress.

Sexual Ambiguity and Stratagems

Beyond this official motive, the lovers' separation is doubtless the result of Geneviève's stratagems, which we must now consider from another perspective. We have already noted that Carole's sexual ambiguity accounts for a good deal of her effect on Geneviève and Gilles. We do not know whether it is her boyishness or her immaturity that pleases Gilles. Her revelation of her homosexual experiences with Béatrice, far from shocking him, only intrigues him more, as it gives her an aura of nonconformism. Who knows whether it doesn't please some deeper level of his being as well? Gilles seems fascinated by feminine homosexuality, as a dialogue between husband and wife in *Tous les chevaux du roi* tends to confirm. Geneviève admits to her husband that she is becoming attached to Hélène: "And looking at her closely, she's much more beautiful than Carole" (*Chevaux*, 97). To which Gilles

replies, "With Hélène, I like you even more than with Bertrand." (97). Geneviève, who knows her man well, admits in turn, "I knew it. I did it for you" (97).[20]

When he first meets Carole, Gilles is attracted because she's young, she's intelligent, she sings songs he likes, and she paints. Above all, she embodies the myth of the androgyne, which seduces him with its mix of archaism and modernity.[21] On a deeper level, Carole reveals to Gilles an unknown dimension of his own personality, that is, the homosexual desire that he cannot otherwise admit. If in her turn, Carole's affair with Gilles realizes her fantasies of transgressing the Oedipal taboo, by displacing them from her stepfather to Gilles, so Gilles realizes his own: by seducing a girl, with a boy's attractiveness, he gives himself over to a "homosexual" love without taking it on directly—that is, at once innocently and in bad faith. The lovers, Gilles and Carole, understand each other less on a superficial level than on the level of the unconscious, in that they each realize, by means of the other, a part of the fantasies that structure their deep personality. They are, reciprocally, the image of what they desire, and do not know they desire.[22]

Geneviève must enter into this dialectic of the image and destroy its charms. By keeping Bertrand on as a lover, first of all, she places herself on equal terms with Gilles. Where Gilles has a young lover who paints and formulates ideas that seem a little dated to the couple, Geneviève takes a young lover with an interest in poetry. Once again, the young man's style seems completely outmoded to the two Situationists (*Nuit*,

100–104). Where Geneviève tolerates Carole's presence, Gilles puts up with that of Bertrand. Gilles, however, upsets the system by paying too much attention to Carole. We have already noted, however, that Geneviève finds Carole attractive. The girl allows Geneviève to cosset her, and confides in her. At a certain point in the story, relations between the women are so friendly that they end up, at least implicitly, distancing themselves from Gilles: "To the point that Gilles will vanish, little by little, from their relations; he will no longer be the obligatory term (or mediator), and indeed, between the two women, agreement will no longer need to pass through his intermediary" (98). Such a state of affairs presents a thinly disguised threat for Gilles, in that the two women now communicate without his mediation, without the help of masculinity. In other words, Gilles risks losing his manly privilege as a mediator between women. If Carole and Geneviève themselves became a couple, giving and receiving pleasure without Gilles, it would mean Gilles's "symbolic castration," or, at the very least, his expulsion from the drama. As we have seen elsewhere, Debord is obsessed by masculinity; he seeks to pass for a "tough guy," no matter what the cost, in order to distance himself from any doubt of his own virility.

On her return from summer vacation, Geneviève at last finds an adequate stratagem. Ridding herself of Bertrand, she becomes Hélène's lover. In doing so, she realizes Gilles's secret fantasy, that is, to have the woman he loves love another woman. Geneviève, who resembles Carole in some ways,

takes the place of her young rival when she in turn realizes the *image* that is at the heart of Gilles's relation to his mistress. Geneviève will offer him the same image, relegating Carole to a secondary role in the drama of their obsessions. Geneviève will become Dominique anew; she will take back her old place by Gilles's side, which a stranger tried to usurp.

Aware of the different stakes in their battle, Geneviève and her husband meet upon his return from Holland. They each have their cards to play. Gilles can replace Geneviève with Carole; Geneviève can destroy Gilles in a still more fundamental way, by depriving him of his masculinity, and thus reducing him to nothing. "Then it's war!" Valmont declares to Madame de Merteuil in *Les Liaisons Dangereuses*. Gilles and Geneviève, faced with a similar situation, seem to declare "Then it's peace!" They make up in a sort of "potlatch," where each strives to be as "generous" (in the Corneillian sense of the term) as the other. Gilles gives up what's precious to him, his love for Carole; Geneviève in return ends her affair with Hélène, who, like Carole, finds herself sacrificed on the altar of the couple's reconciliation. Over the course of her negotiations with her husband, Geneviève

"will allow into the drama the conditions of an exchange, of a potlatch of complicity, namely, that Gilles will not be able to act less forcefully than she will, and that his leaving Carole unconditionally will be the first proof of his detachment, of his freedom. And she will make him understand that, unless this reciprocity is observed, it will mean the end

of their old complicity. All this will be veiled in irony, in caution, but it will be clear enough all the same" (173–174).

By acting thus, Gilles will prove that he behaves "like a man," that he can break off an affair without regard for the consequences to his mistress.

Thus Geneviève shows herself to be a master strategist. Even as she maintains the appearance of a woman subjected to her husband's desires, she shows him, in no uncertain terms, what he risks if he goes too far. If he has affairs with young girls, fine, but he may not become emotionally involved in a lasting relationship, which would shatter the traditional concept of the couple. In the game of "gift-counter-gift," Gilles is the loser. Of the two, he has more to lose.

The values of the Situationist movement are steeped in the culture of heroism. At the center of this culture stands the masculine figure as uncontested mediator of all exchanges. When she disrupts this position, Geneviève threatens not only a man, but an entire system that is unaware of the imaginary presuppositions on which it is founded. Gilles is unprepared to confront this dimension of his own praxis; he chooses to give up his lover, rather than to see the superiority of the "phallus" thrown into question.

Conclusion

I may be reproached for this descent into the private life of the Situationists. My perspective is neither academic, nor

usual among contemporary analysts of their saga. It is obvious that I have not taken into account the movement's revolutionary contribution to art or to everyday life. Why linger over novels whose own author finds them insignificant? According to the Situationists themselves, authors such as Charles Fourier or Mikhail Artzybashev have played an important part in their definition of love. However, if we rely on Bernstein's two novels, we discover that the Situationist practice is in total opposition to the freedom promoted by a character such as Artzybashev's Sanin (*Sanin*, 1907). Far from letting themselves be overwhelmed by passion, Gilles and Geneviève try to control it in order to maintain their power on the other characters. Even if they do not acknowledge their true intellectual affiliation, their world is closer to that of the aristocratic libertines of the eighteenth century than to the Surrealists.

The Situationist movement avoids any analysis of the psychological dimension of human behavior, whether their own or anyone else's. It would like to overlook the part played by the irrational in any action, preferring to conceive of men as rational beings, capable of controlling themselves, the better to control others. We have nevertheless found our investigation of the few documents available on the subject to be fruitful. On the one hand, this study shows us the degree to which the Situationists, above all Debord, were fascinated by the image. If they denounce the spectacle, it is because they are its best *spectators*, as is evident from the importance of certain films, images, and cultural themes in the work of their

chief theoretician. On the other hand, our investigation allows us to grasp the subjective, *untheorized* practices of those who participated in the Situationist adventure. This in no way diminishes the value of Debord's analyses, but it does give us a sense of their scope, and of their limits.

Université Stendhal, Grenoble III
— translated by Paul Lafarge

1. Debord offered some of these keys with the publication of a critical edition of this text in 1990.

2. In his memoir, *Un cavalier à la mer*, Gérard Guégan goes on the offensive again, this time without the help of fiction; he evokes Debord numerous times in the book, mostly for the purpose of maligning him.

3. "'They were jokes,' she said in 1983" (Marcus 423).

4. Marcus agrees with Bernard Pingaud, who in the preface to *La Nuit* had remarked: "The novelist had meanwhile changed her model, from Sagan to Robbe-Grillet" (12).

5. In the first text, it appears right under Bernstein's photo (36); in the second, it can be found in the thirteenth plate of the third part. It figures there not as a citation from de Retz's *Memoirs* (which Debord had doubtless not read at the time), but as an excerpt from a recent book by Pierre-George Lorris on the Cardinal de Retz and the Fronde. (Lorris 1956).

6. Among the pieces she sings on that evening, we can note a 17th or 18th century song, "Aux marches du palais," from which Bernstein's novel takes its title. The words to this song may be found in Segher 153–4.

7. This dialogue appears again in André Bertrand's *détourné* comic strip, *Le retour de la colonne Durruti*, which appeared in 1966. The panel in which this exchange appears has been published in a number of places, including Marcus's work (Marcus 425).

8. A man of many talents—he was a painter, an engraver, a ceramicist, a tapestry designer, essayist, theoretician of art and a philosopher—Jorn had an international reputation by the end of the 1950s. The list of his publications between 1957 and 1961 is impressive (Cf. Atkins, G and Erik Schmidt 1964). Bernstein paints a more detailed portrait of Jorn in *La Nuit*, where she presents him as a relaxed host, ironic and bohemian.

9. *On the Passage of a Few Persons Through a rather brief period of time*, 1959; *Critique of separation*, 1961.

10. "Guy had a tremendous amount of culture and ideas that were extraordinary enough at the time, or even for the years that followed. Bernstein was completely different; she had an exceptional classical education, and knew lots of things. For me and for others, at the time, she was a walking dictionary; she had a very cultivated background" (Mension 113).

11. Debord includes several scenes from *Les Visiteurs du Soir* in his last film, *In girum* (1978). Cf. *Oeuvres cinématographiques*, 253, 255, 277.

12. In his last film, Debord speaks of the Latin Quarter as a sort of den of thieves where, in the early 1950s, young people who struck terror into the hearts of right-thinking folk used to meet. "In this place which was the brief capital of disturbances, even though it might have been true that the select company included a certain number of thieves, and occasionally murderers, the existence of all was mainly characterized by a prodigious inactivity; and it was this that was resented as the most threatening of so many of the crimes and offences discovered there by the authorities" (*In girum* 36-37).

13. Later, Bernstein remarks again, "Twin and dear sisters, childish and authoritarian, in their room as on stage, and more beautiful because they

looked so much alike, a resemblance, it's true, achieved through artifice, but none the less touching for all that. Carole came off as the more perfect toy, more elegant, funnier, and finer in her details" (176).

14. Debord's fascination with the chivalry of the late Middle Ages, which he got from the work of Huizinga, can be found also on Alice Becker-Ho's recent collection of poetry, *D'azur au triangle vidé de sable*.

15. We have seen earlier that, in the economy of the story, Carole plays the part of Anne in Prévert's screenplay; Dominique's role belongs only to Geneviève.

16. We find a similar image in the film *Critique of separation*. Cf. Bracken 107.

17. "It is unclear why Geneviève will find it opportune (or rather, she will know all too well that it is not opportune, and will do it with all the more pleasure and feigned clumsiness, faced with her husband's willfully absent attitude) to think of the little space, or rather the little time Carole will be allowed in Gilles's life, precisely on account of this complicity, of this confidence, the importance of which Gilles will not be able to deny at this moment in his story, which she will destroy in advance—the importance of his adventures, of his pleasures" (97).

18. Cf. 32, 74, and 144–45 of the novel.

19. Geneviève evokes for a moment "the rigid frame of conventions that they have fixed for themselves once and for all, certainly a long time ago—or perhaps, if she thinks about it, not once and for all after all" (77).

20. In *In girum imus nocte*, Debord includes images of his second wife, Alice, in the arms of his mistress, Celeste. Cf. *Oeuvres cinématographiques*, 273, and photo No. 20 of the dossier that accompanies the film. Alice Becker-Ho herself confirms that she shared lovers with her husband in her poem, "The New Favorite." Cf. Becker-Ho 13.

21. Cf. Libis 1980.

22. Debord's emotional and intellectual universe is marked by a fascination for "real men," whether thugs like Ghislain de Marbaix, bandits like Villon or Lacenaire, or simple soldiers. Note the importance of westerns and war movies in his personal mythology, in which we may also recognize a relatively distinct, though latent, homosexuality. We see above all an attraction for everything that Debord didn't dare or couldn't do himself. For more on Ghislain de Marbaix, a thug and pimp who was assassinated doubtless by a contract killer, see his anonymous memoirs, dictated to Randal Lemoine in 1967: *Monsieur Gontran*. The book, although it makes no direct reference to Debord, covers the same period as Bernstein's novels. Debord pays homage to Marbaix again and again in his films and in his last writings: "There had been that 'noble man' among my friends who was the complete equal of Régnier de Montigny, as well as many other rebels destined for bad ends" (*Panegyric* 26).

WORKS CITED

ARTSYBASHEV, Mikhail, *Sanin*. New York: Illustrated Editions Co., 1932.
ATKINS, Guy and Erik Schmidt. *A Bibliography of Asger Jorn's Writings to 1963*. Copenhagen: Permildt and Rosengreen, 1964.
BECKER-HO, Alice. *D'Azur au triangle vidé de sable*. Cognac: Le temps qu'il fait, 1998.
BERNSTEIN, Michèle. *Tous les chevaux du roi*. Paris: Buchet-Chastel, 1960.
— *La nuit*. Paris: Buchet-Chastel, 1961.
BRACKEN, Len. *Guy Debord—Revolutionary*. Venice, Ca: Feral House, 1997.
CARNÉ, Marcel and Jacques Prévert. *Les Visiteurs du Soir* (film). 1942.
DEBORD, Guy. "10 ans d'art expérimental: Jorn et son rôle dans l'invention théorique," in *Museum Journal*, vol.IV, no. 4. Pub. Otterlo: October 1958.
— *Mémoires*: 1959. Paris: Les Belles lettres, 1993.
— *Comments on the Society of the Spectacle*. London: Verso, 1990.
— *Oeuvres cinématographiques complètes*, (1978). Paris: Gallimard, 1994.
— *In girum imus nocte et consumimur igni*. Edition commentée. Paris: Gérard Lebovici, 1990.

— *In girum imus nocte et consumimur igni. A film.* Trans. Lucy Forsyth. London: Pelagian Press, 1991.

— *Panegyric.* Trans. James Brook. London: Verso, 1991.

— *"Cette mauvaise réputation…".* Paris: Gallimard, 1993.

GONZALVEZ, Shigenobu. *Guy Debord ou la beauté du négatif.* Paris: Mille et une nuits, 1998.

GUÉGAN, Gérard. *Les Irréguliers.* Paris: J.-C. Lattès, 1975.

— *Un cavalier à la mer.* Paris: François Bourin, 1992.

HUIZINGA, Johan. *The Autumn of the Middle Ages.* Chicago: University of Chicago Press, 1996.

LACLOS, Pierre Choderlos de. *Les Liaisons dangereuses.* 1782. Oxford: Oxford University Press, 1995.

LEMOINE, Randal. *Monsieur Gontran.* Paris: Julliard, 1968.

LIBIS, Jean *Le mythe de l'androgyne.* Paris: Berg International, 1980.

LORRIS, Pierre-Georges. *Un agitateur au XVIIe siècle. Le cardinal de Retz.* Paris: Albin Michel, 1956.

MENSION, Jean-Michel. *La tribu.* Paris: Allia, 1998.

MERCIER, Luc, ed. *Archives situationnistes*, vol.1. Paris: Contre-Moule/Parallèles éditeurs, 1997.

MARCUS, Greil. *Lipstick Traces. A Secret History of the 20th Century.* Cambridge: Harvard University Press, 1989.

INTERNATIONALE SITUATIONNISTE, no. 2, 1958, 2nd ed. Paris: Fayard, 1997.

RACINE, Jean. Complete Plays. New York: Random House, 1967.

RAJSFUS, Maurice. *Une enfance laïque et républicaine.* Levallois-Perret: Editions Manya, 1992.

POTLATCH, Paris: rééd. Folio, Gallimard, 1996.

SEGHERS, Pierre ed. *Le livre d'or de la poésie française.* Paris: Marabout Université, s.d. 1962.

Printed in the United States
by Baker & Taylor Publisher Services